DARTMOOR

THROUGH THE YEAR

Derek Tait

AMBERLEY PUBLISHING

Acknowledgements

Photograph Credits

Derek Tait and Tina Cole. Thanks also to Tilly Barker.

Bibliography

Books
Plymouth Through Time (Amberley, 2010)
Saltash Through Time (Amberley, 2010)
The Rame Peninsula Through Time (Amberley, 2010)
River Tamar Through Time (Amberley, 2011)
Devon Through Time (Amberley, 2012)
Cornwall Through Time (Amberley, 2012)
River Tamar Through the Year (Amberley, 2012)
Devonport Through Time (Amberley, 2012)

Websites
Derek Tait's website: www.derektait.co.uk
Derek Tait's Plymouth Local History Blog: www.plymouthlocalhistory.blogspot.com

First published 2013

Amberley Publishing
The Hill, Stroud, Gloucestershire, GL5 4EP
www.amberley-books.com

Copyright © Derek Tait, 2013

The right of Derek Tait to be identified as the
Author of this work has been asserted in accordance
with the Copyrights, Designs and Patents Act 1988.

ISBN 978 1 84868 355 6

British Library Cataloguing in Publication Data.
A catalogue record for this book is available from the
British Library.

Typesetting by Amberley Publishing.
Printed in Great Britain.

Introduction

Beautiful and mysterious, Dartmoor covers an area of 368 square miles. Today, it is managed by the Dartmoor National Park Authority.

Throughout the year the area is constantly changing, as is the weather; it is sunny one moment, stormy the next. Spring brings new bloom to the area with new flowers, animals and varied insect life. With the warmer weather of summer, there are many visitors to the moor exploring all it has to offer. The annual Ten Tors Challenge takes place every May and includes teams of young people. The event is organised by the Army. The weather during the event is often unpredictable as is Dartmoor.

Autumn produces beautiful colours, particularly in the many small villages, as the trees begin to lose their leaves.

In the winter, many parts of the moor become impassable during heavy snowfall, and villages can be cut off for days.

There is an abundance of wildlife on Dartmoor, including deer, wild boar, stoats, foxes, voles, wood mice, dormice, grey squirrels and badgers. Various varieties of sheep and cows are grazed all over Dartmoor as well as the world famous Dartmoor ponies, which, today, are dwindling in numbers.

The area is steeped in history. Prehistoric remains on the moors date back to the Neolithic period and the early Bronze Age. The remains of standing stones, hut circles and kistvaens can be found scattered all across Dartmoor. The area contains the largest concentration of Bronze Age remains in Britain. During Bronze Age times the climate was a lot warmer than it is today, and much of the now barren moorland was once covered in trees. Most were cleared by prehistoric settlers to create farmland. Many parts were burned and used as grazing areas for livestock, and this practice led to soil acidification. As a result, much of the moors has remained bleak and barren for thousands of years with no new tree growth.

Dartmoor Prison was built by local workers between 1806 and 1809 and housed prisoners from the Napoleonic Wars. From 1813 until 1815, it also housed American prisoners from the War of 1812. It was reopened as a civilian prison in 1851 but closed in 1917. It became a Home Office Work Centre for conscientious objectors during the First World War years, and in 1920 it once more reopened as a civilian prison and housed some of Britain's worst offenders.

Many ghost stories and legends feature Dartmoor. Perhaps the most well-known is the tale of the hairy hands. The story tells how many motorists travelling on the road to Postbridge have had their steering wheels grabbed by a mysterious pair of hands, which has forced them off the road. The tales stretch back to 1910, and local legends say that the hands belong to a man killed on the road.

Sir Arthur Conan Doyle included the haunting backdrop of Dartmoor in several of his stories including, most notably, *The Hound of the Baskervilles*, which was

published in 1902. It refers to the local jail as Princetown Prison and features in its plot an escaped prisoner. Walking the moor today and visiting some of the eerie tors, particularly during poor weather, it's easy to imagine the world of Sherlock Holmes as he searched for the mysterious beast.

Nevil Shute's first novel, *Marazan*, which was published in 1926, featured a convict escaping from Dartmoor Prison onto the desolate moor. The area has also been featured in books, films and television shows regularly ever since, and the haunting atmosphere of the moor greatly adds to many dramas.

I've tried to capture the area in all its beauty throughout the year, and I hope this book will prove appealing to all lovers of Dartmoor.

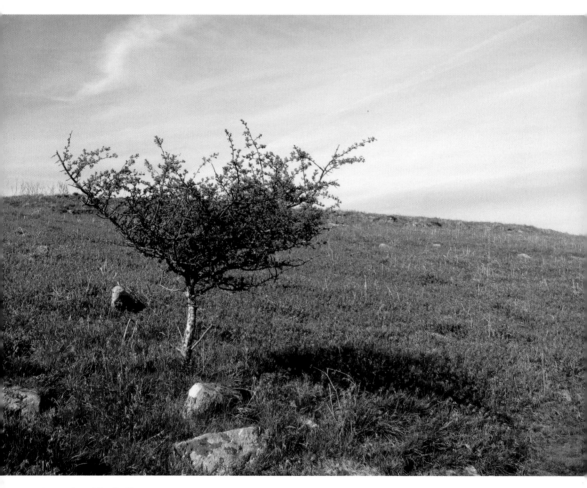

Stunning Bluebells
A spring photograph of a beautiful carpet of bluebells at Holwell Lawn, close to Hound Tor.

SPRING

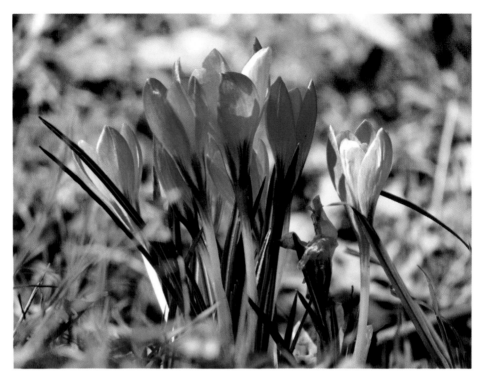

Spring Flowers

The two photographs show both crocuses and daffodils as they bloom on Dartmoor in early spring. The flowers add a carpet of colour to Dartmoor, especially in many of the small villages and towns found across the National Park. Both varieties are often dug up by mice, squirrel and rabbits searching for food but, if left alone, should bloom every year.

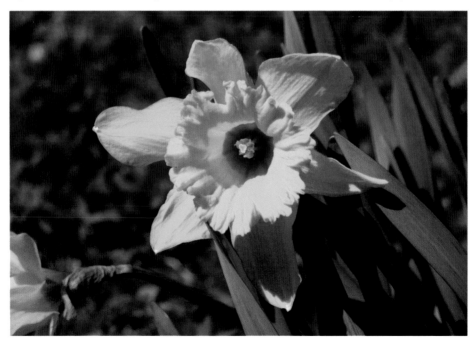

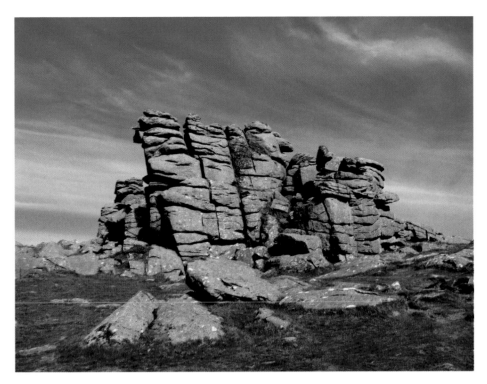

Mysterious Tors

The first photograph shows Hound Tor, which is situated between Bovey Tracey and Widecombe-in-the-Moor. To the south-east are the remains of an old medieval village called Hundatora. Also nearby are Bronze Age hut circles. The second photograph shows the bluebells at Holwell Lawn, which is close to three tors – Hound Tor, Hay Tor and Holwell Tor.

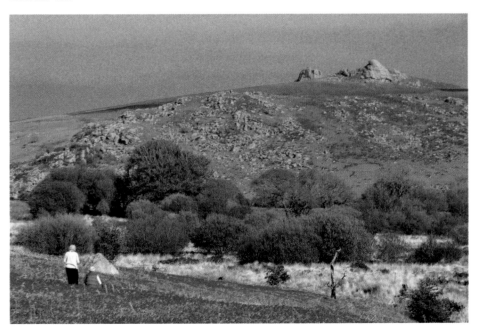

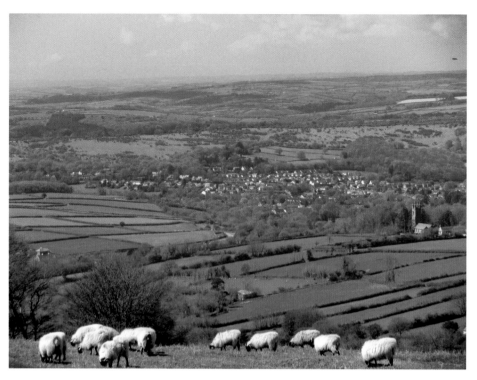

Grazing Sheep

In the first photograph, sheep graze on the banks of Dartmoor. Walkhampton church can be seen in the background. Farming has taken place on the moors for over 5,000 years. In the second photograph, a new lamb wanders among the granite boulders of a nearby tor.

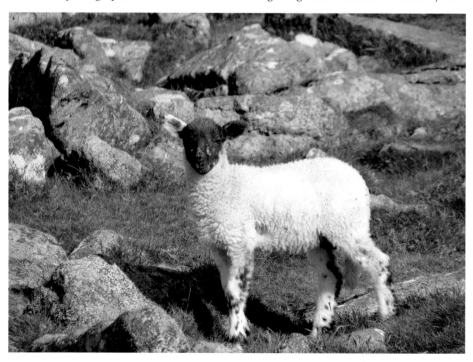

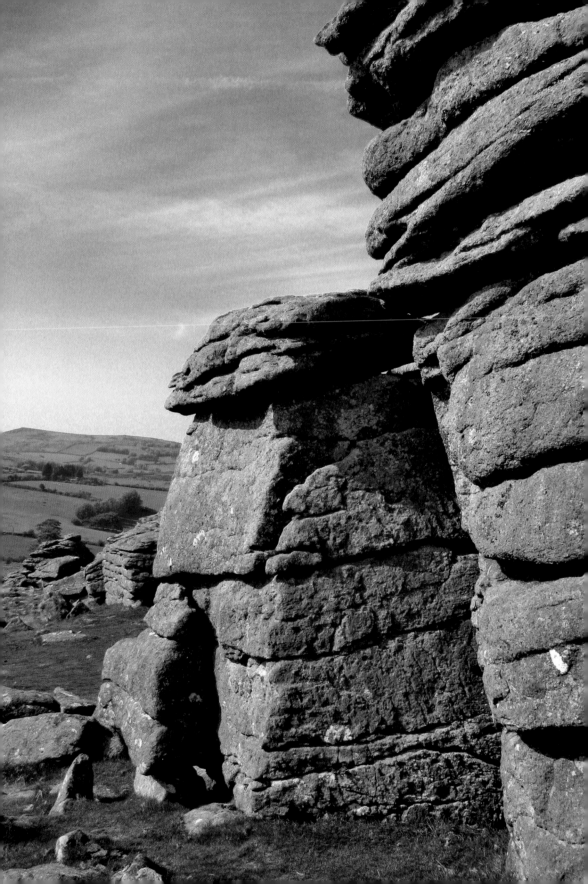

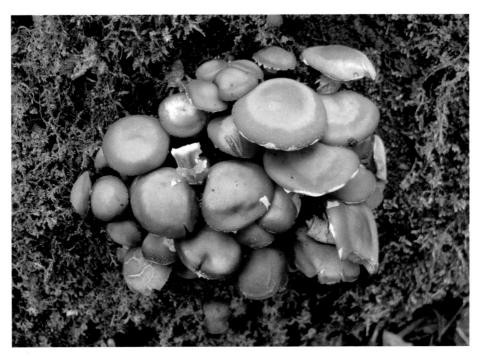

Flora & Fungi

There are many different types of fungi found all over Dartmoor. These include the oddly named big blue pinkgill, waxcap, earth tongue and fairy club. There are two main recognised areas for fungi on Dartmoor. These are at Bellever Forest and Spitchwick Common. The ideal habitat for fungi is woodlands, old trees and old grasslands.

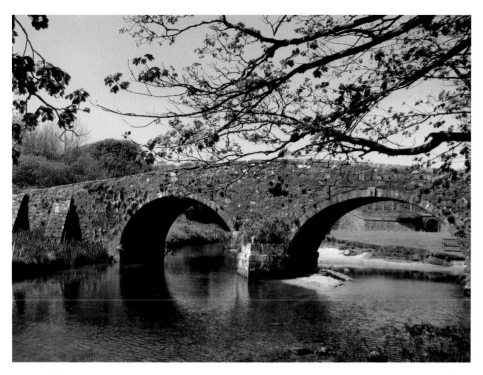

Two Bridges

Two Bridges can be found in the heart of Dartmoor, around 1½ miles north-east of Princetown. The name comes from a time when two bridges crossed the West Dart and the River Cowsic. By 1891, these bridges had disappeared and there was just one bridge further downstream. In recent years, to cope with traffic, there are once again two bridges. A more recent holed stone stands on the lawn adjoining the Two Bridges Hotel.

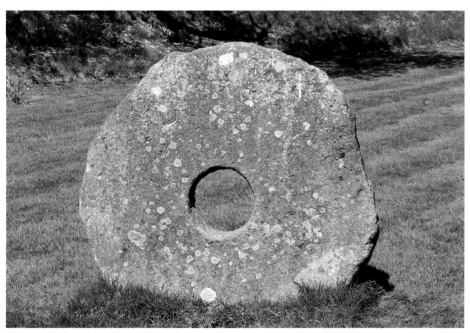

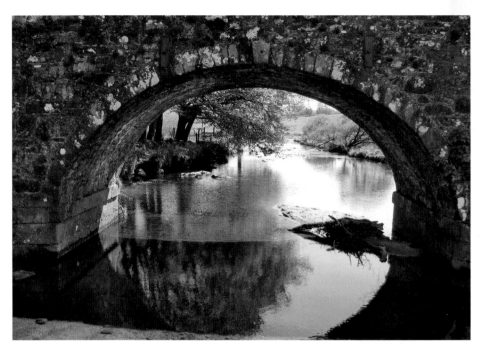

The Old & The New

The view through the arch of the older bridge at Two Bridges can be seen in the first photograph. The newer bridge at Two Bridges was built in 1931. In the 1700s, there was a popular potato market in the area. The second photograph shows the small shop at Postbridge, complete with a milk churn and an old red phone box. Nearby is the well-known clapper bridge, which crosses the East Dart River.

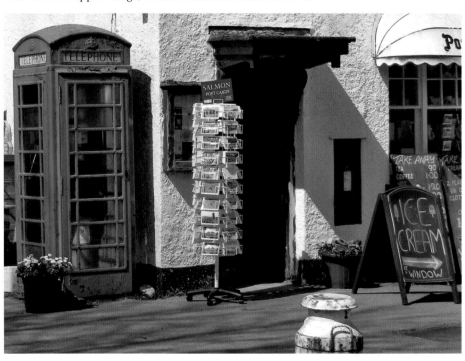

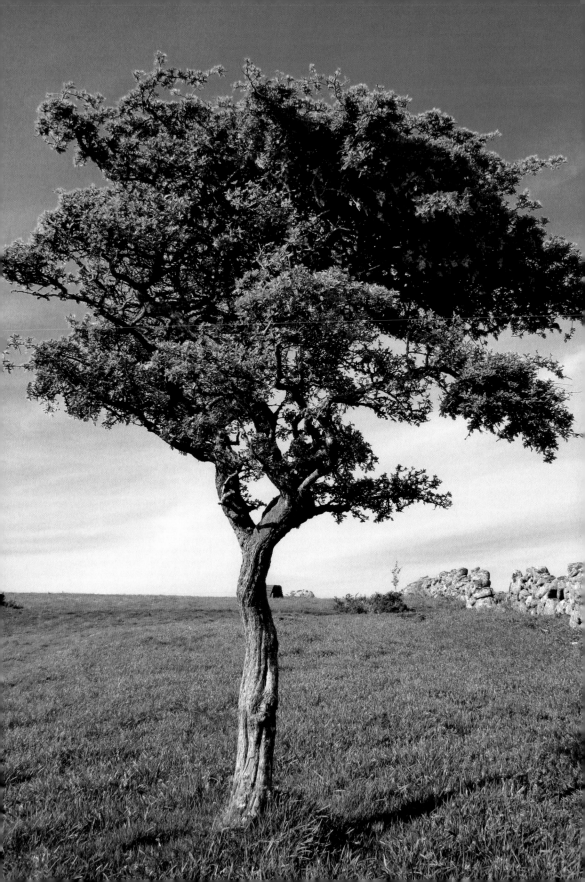

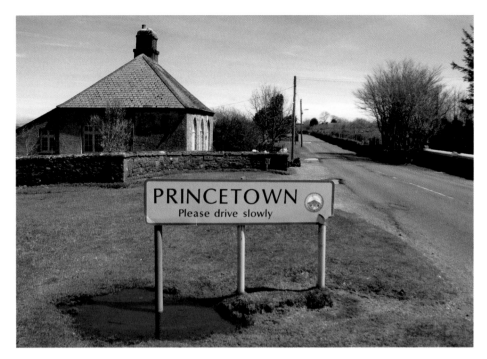

The Ten Tors Challenge

Every May, young people take park in the Ten Tors Challenge. The hike takes place over a weekend and involves approximately 2,400 participants. Teams are made up from members of schools, colleges, scout groups and cadet squadrons. The teams have to visit ten tors on the moor. There are twenty-six different routes involving a total of nineteen different tors.

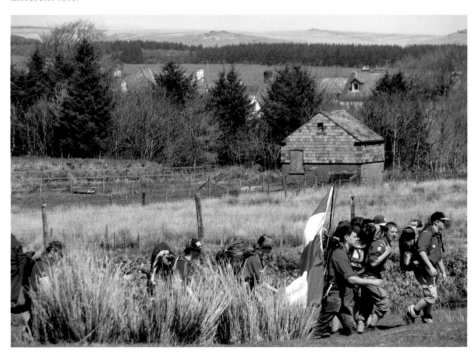

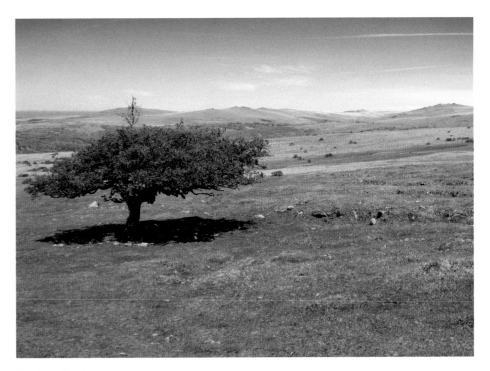

Much to Explore

The first photograph shows the magnificent view across the moors from the road on the way to Princetown. The second photograph shows the much-visited clapper bridge at Postbridge. The bridge probably dates back to the 1300s but the earliest recording of it appears in a lease of 1655. Each slab of the bridge is 13 feet long and weighs over 8 tons.

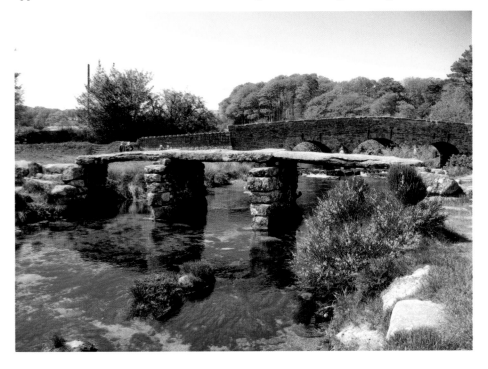

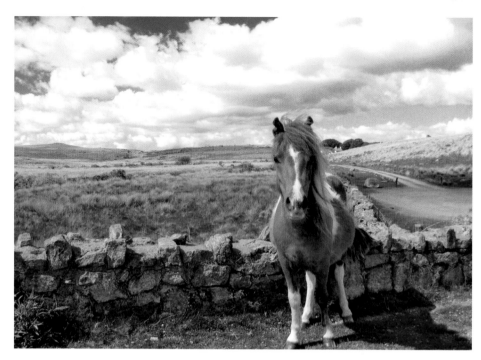

Wild Ponies

The Dartmoor pony has existed on the moors for centuries. In the past they were used by tin miners and quarry workers, but their numbers have dwindled greatly over the years and there are only a few hundred grazing on the moor today. The conditions on Dartmoor make them a particularly hardy breed with plenty of stamina.

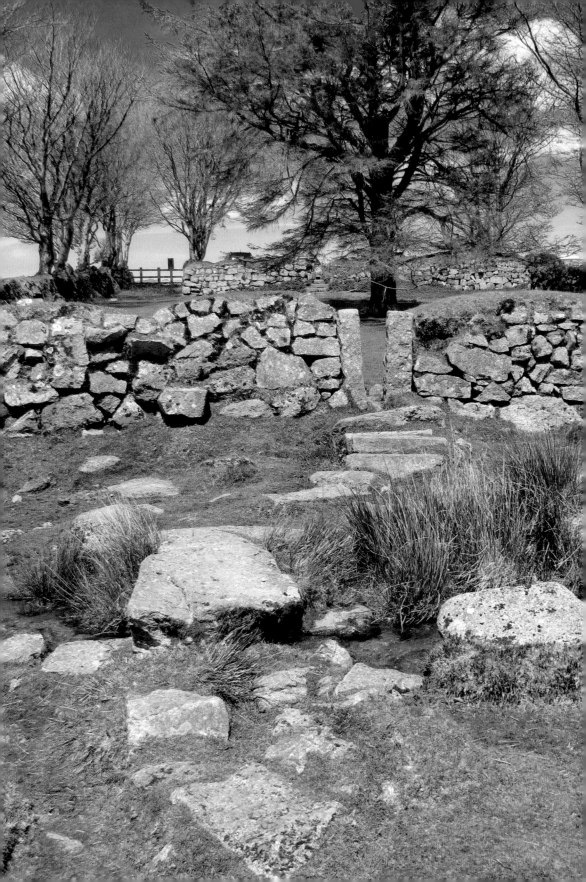

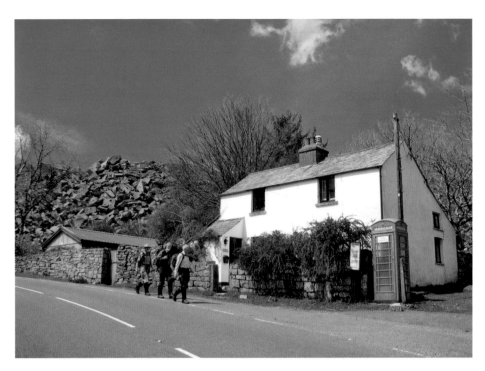

Quarried Stone

Walkers can be seen passing the quarry at Merrivale in the earlier photograph. The hamlet lies in the civil parish of Whitchurch and the few buildings were originally built to house quarry workers. The quarry finally closed in 1997. The Dartmoor Inn is situated close by. To the south are Bronze Age megalithic monuments, including a standing stone and stone circles.

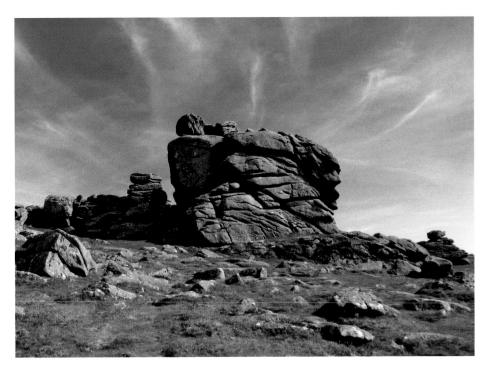

In the Shadow of Sherlock Holmes

Sir Arthur Conan Doyle set *The Hound of the Baskervilles* on Dartmoor and, when walking through the rocks at Hound Tor on a misty day, it's easy to imagine that you might meet the creature mentioned in the book. Close to the tor are the remains of prehistoric settlements, Bronze Age hut circles and the remains of a medieval village.

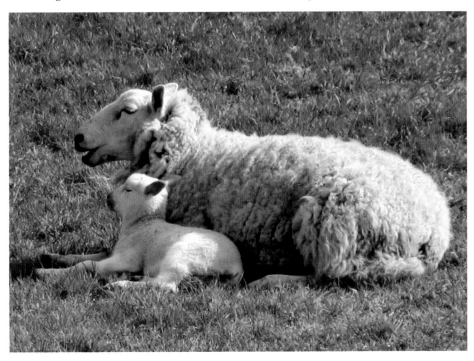

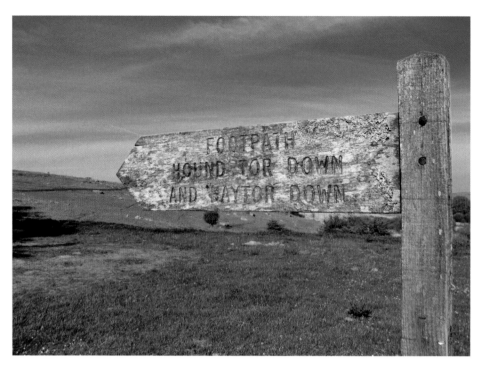

Bluebells at Holwell Lawn

Every spring, Holwell Lawn produces a beautiful spread of bluebells, which attracts many visitors and particularly photographers. Holwell Lawn forms part of Manaton and features a cross-country horse riding course. Views from the lawn stretch across the valley to both Holwell Tor and Haytor Rocks. Also close by is Hound Tor.

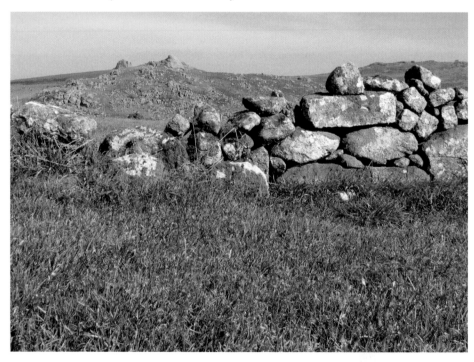

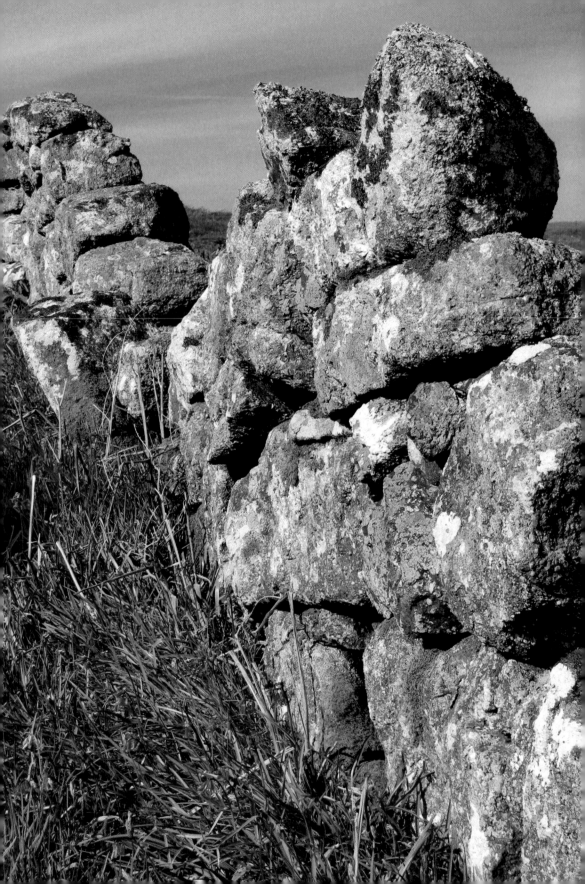

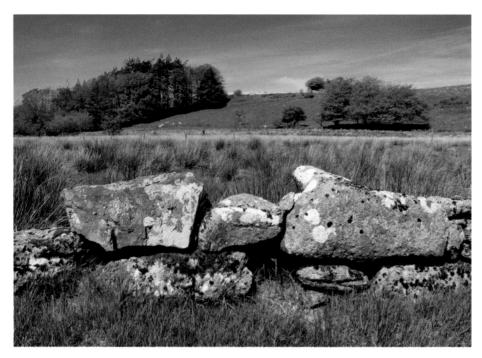

Granite Walls

Locally mined granite has been used to construct the walls on Dartmoor for hundreds of years. Many are covered in different varieties of lichens and mosses, and are protected under the Wildlife & Countryside Act. Perhaps the most unusual lichen found is 'string-of-sausages', which is easily recognisable and signifies clean air.

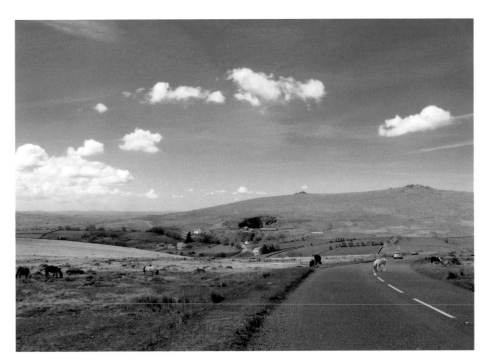

Quiet Roads

The roads crossing Dartmoor can, at times, be very peaceful, but care has to be taken because of the many sheep, ponies and cows that wander across them. In the first photograph, several ponies graze nearby. The abandoned granite mine at Merrivale, where years of work has left a huge crater, can be seen in the background. The second photograph shows a cyclist enjoying the quiet road.

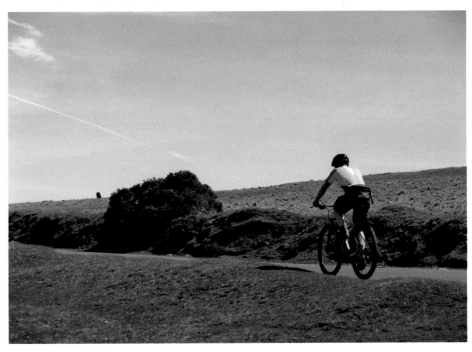

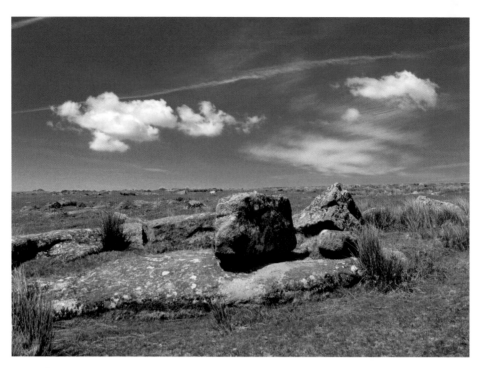

Beautiful Wilderness

Around 300 million years ago, the tors and Dartmoor granite formed from a molten rock known as magma. Many boulders lay scattered exactly where they landed at this time. The rock has been used as building stone since the Bronze Age, approximately 4,000 years ago.

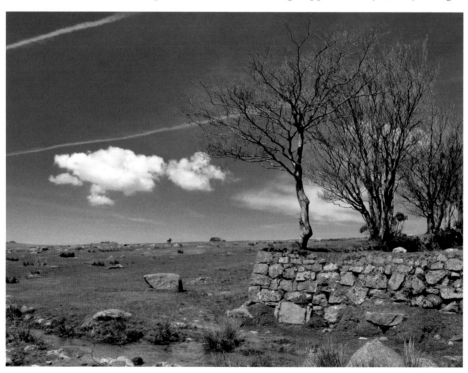

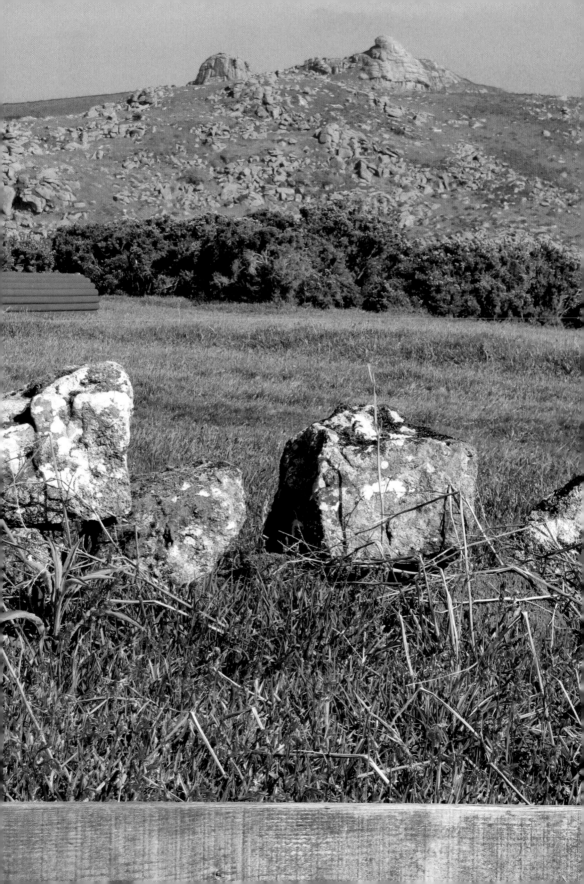

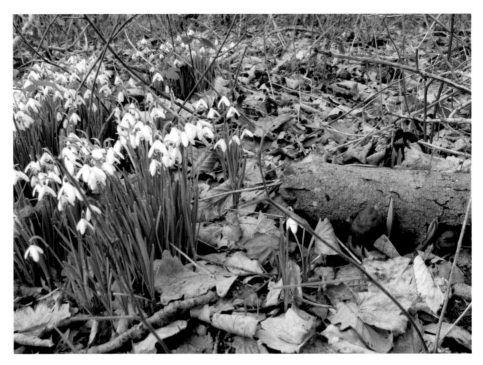

New Growth

The first photograph shows snowdrops appearing through autumn leaves, while the second photograph shows gorse blooming in spring. Gorse also flowers in autumn and late winter and is extremely hardy. It provides excellent cover for small nesting birds. It is burnt back annually by some farmers in a process known as swaling, which allows new grass to grow and provides grazing ground for livestock.

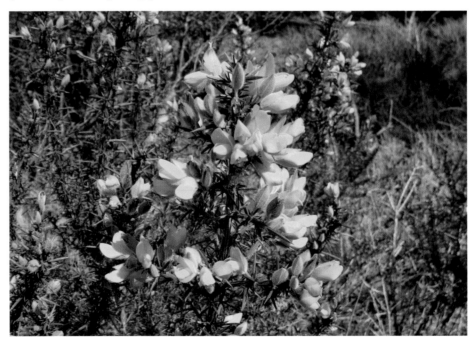

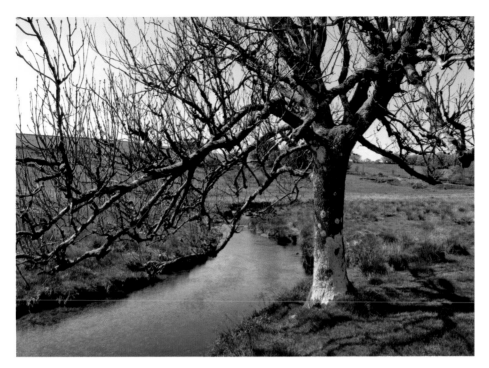

Magnificent Trees

Dartmoor was once covered in trees, but from 10,000 BC, during the Mesolithic period or Middle Stone Age (10,000–4,500 BC), areas were cleared by small groups of hunter-gatherers, who encouraged animals to graze in the cleared areas. During the Neolithic or New Stone Age (4,500–2,300 BC), further tree clearing took place as farms were created for crop cultivation and keeping livestock.

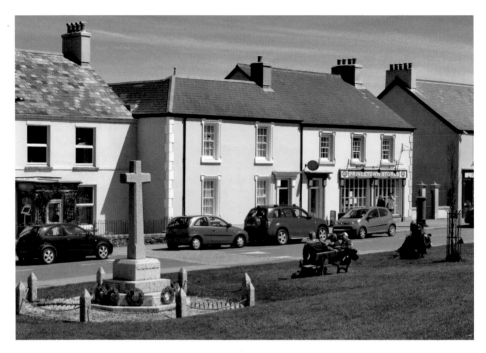

Moorland Visitors

Dartmoor attracts many visitors each year, including ramblers, rock climbers, mountain bikers, horse riders and general tourists. The photograph above shows the village of Princetown, which is most famous for its prison and its Sherlock Holmes connections. The second photograph below shows people enjoying a drink at the Dartmoor Inn at Merrivale.

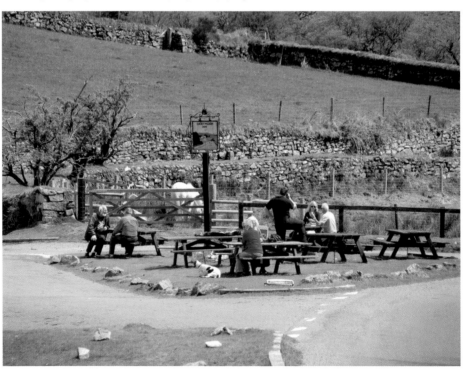

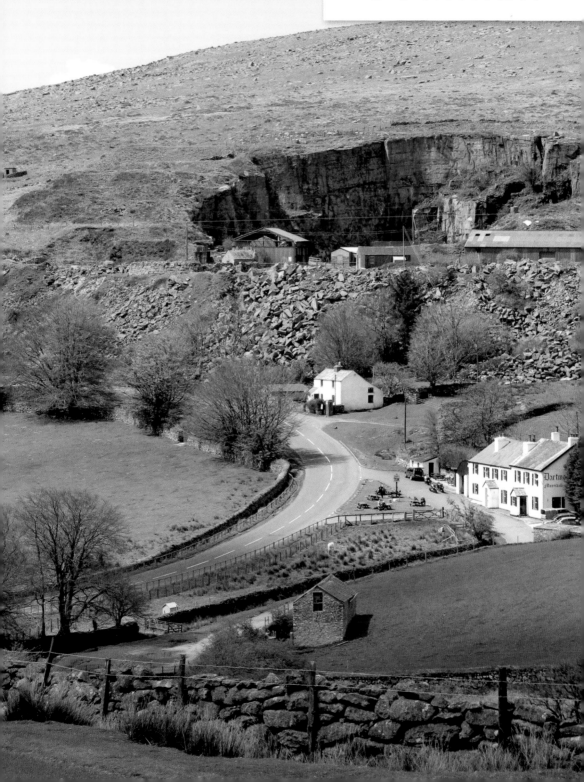

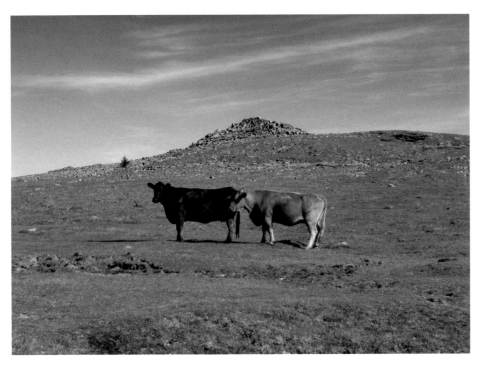

Wandering Cattle

Cattle, sheep and ponies can be found wandering on many parts of the moor. There are several breeds of cattle grazing on Dartmoor including the Aberdeen Angus, the Galloway and the Holstein/Friesian, which are used for their milk production. Holstein/Friesians can be found grazing near Hound Tor.

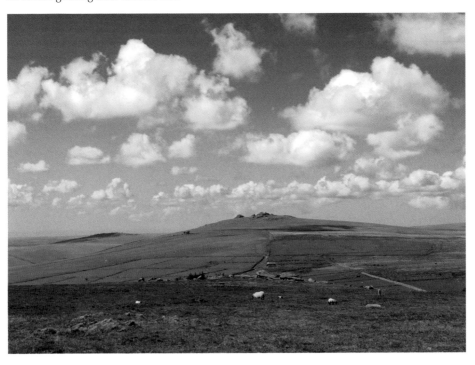

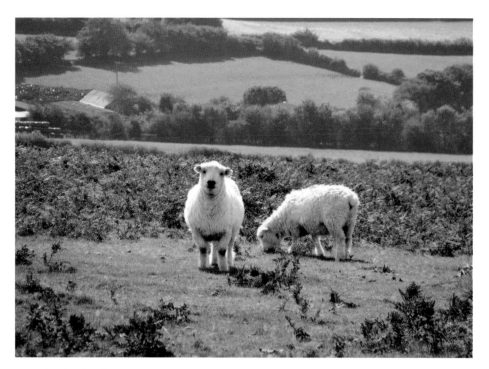

Moorland Wildlife

Varieties of sheep found on Dartmoor include the whiteface Dartmoor, the greyface Dartmoor, the Exmoor horn and the Cheviot, which is raised for both meat and wool. By far the most common breed of sheep on Dartmoor is the Scottish Blackface, which is a hardy breed used in exposed locations. Dartmoor ponies wander freely, often approaching tourists for food.

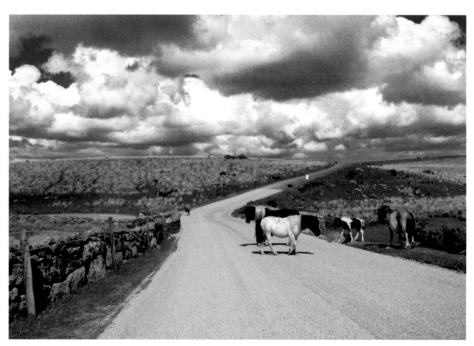

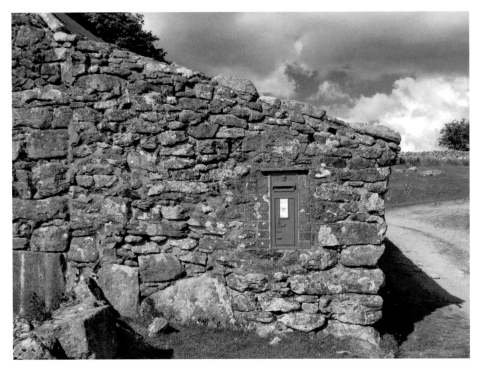

Lonely Farms

Many farms on Dartmoor are in isolated positions well away from neighbours. The first photograph shows a farm that is isolated but has its own postbox. The second photograph shows a farm close to Princetown; its livestock of sheep and cows can be seen grazing nearby.

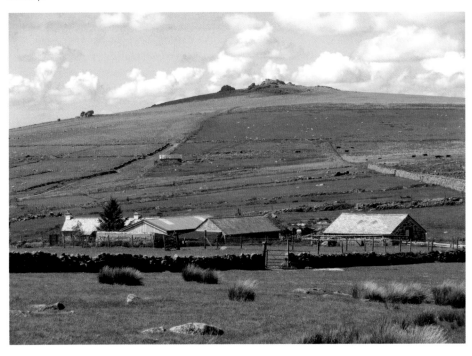

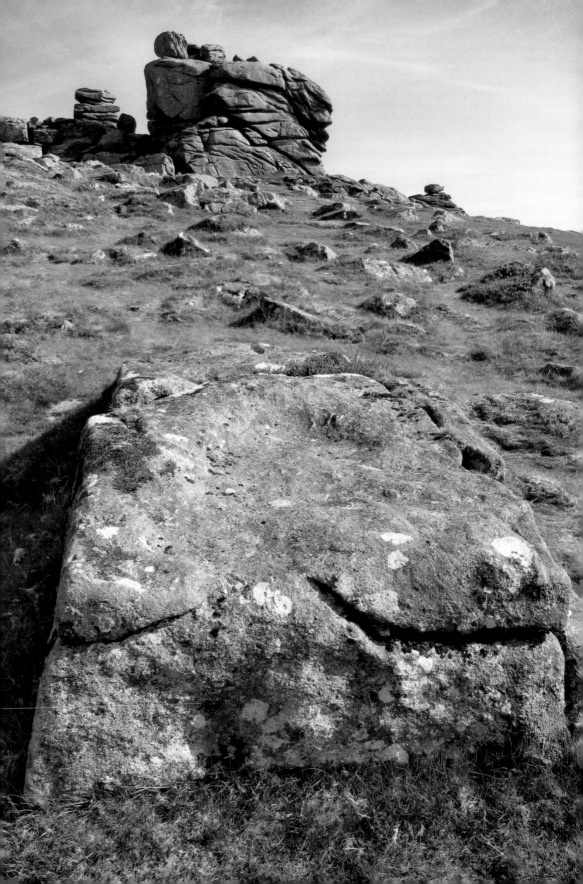

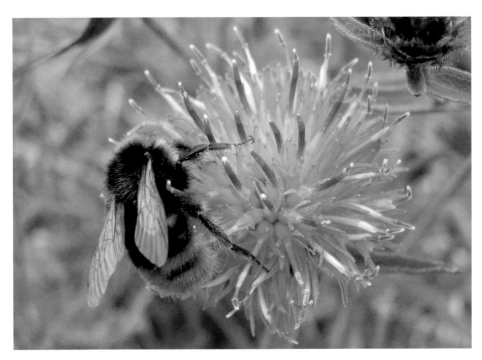

Wonderful Insects

Dartmoor is home to many insects and butterflies, including pearl-bordered fritillaries and high brown fritillaries, which have dwindled considerably in recent years. Other varieties that can be seen include the painted lady, the grayling, the marsh fritillary and the silver washed fritillary.

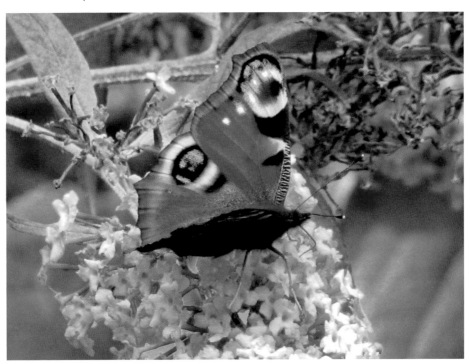

Managed Moorland

Gorse is burnt back annually by some farmers, in a process known as swaling. This allows new grass to grow which provides fresh grazing ground for livestock. Gorse is also burnt back to stop summer wildfires from spreading. Summer fruit can be found on trees throughout Dartmoor, particularly close to many of the small towns and villages.

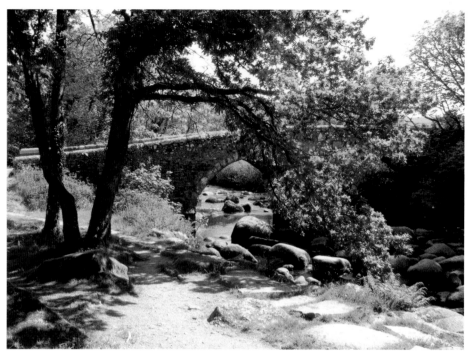

Gentle Waters

Many of the small bridges crossing rivers and streams on Dartmoor were built hundreds of years ago and were originally constructed to accommodate horses and carts. Over the years, with the introduction of cars and other vehicles, the bridges are still in use although many have been strengthened or widened.

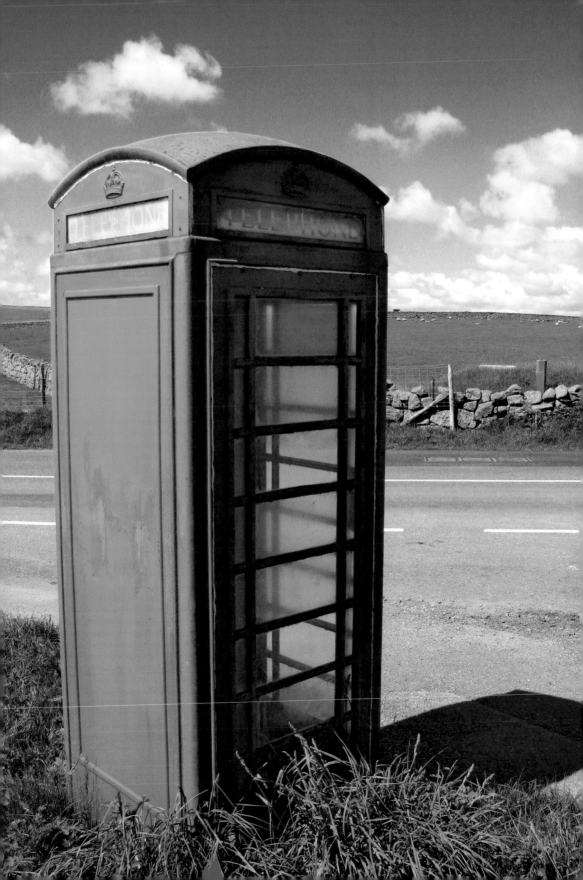

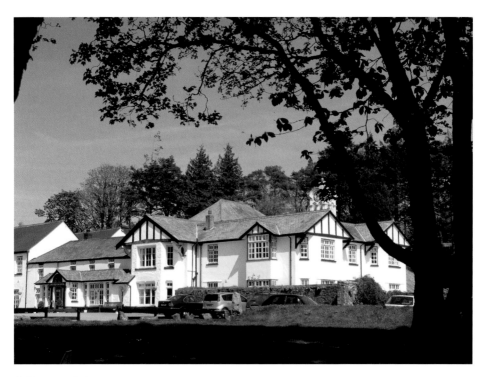

A Country Pub

Both photographs show the popular pub and hotel at Two Bridges. Many tourists from all around the world visit the inn in the heart of Dartmoor. On the roof of the inn is an unusual weather vane, which shows a frog in a waistcoat raising a tankard of beer.

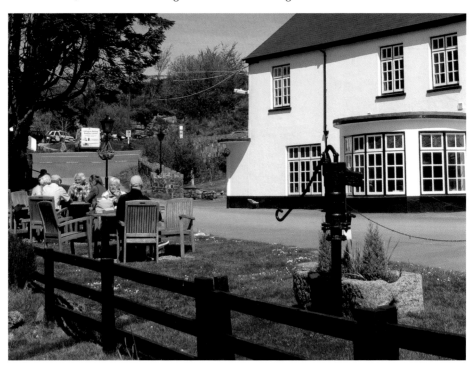

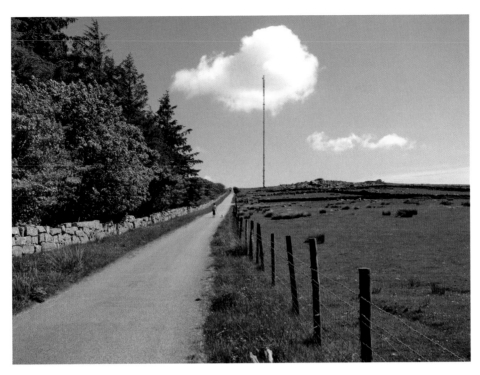

Television Aerial at North Hessary Tor

The transmitting station was built on North Hessary Tor by the BBC in 1955 and the mast stands 643 feet tall. The tor is 1673 feet above sea level, making the transmitting station the second highest in the UK.

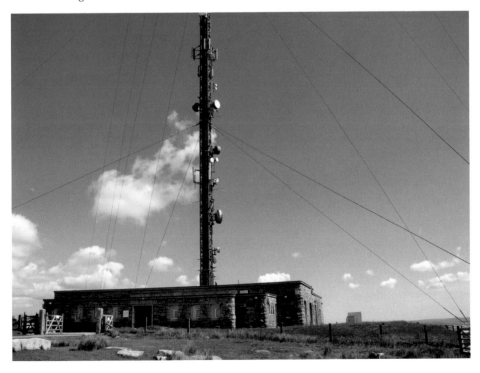

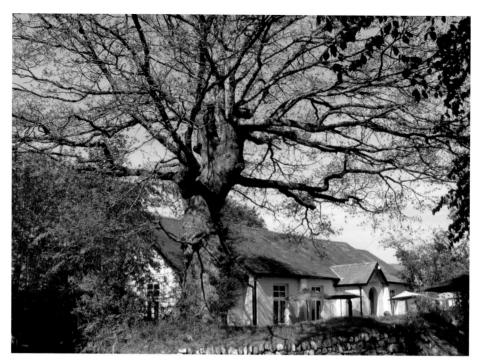

Widecombe Village

Widecombe Fair takes place every year on the second Tuesday in September. Thousands of visitors attend the event, and the fair is commemorated in a folk song most famous for the line, 'and Uncle Tom Cobley and all'. The earliest record of the fair appears in the *Plymouth Gazette* of 1850, which describes the event as a 'cattle fair'. Stalls were introduced in 1933 selling rural wares.

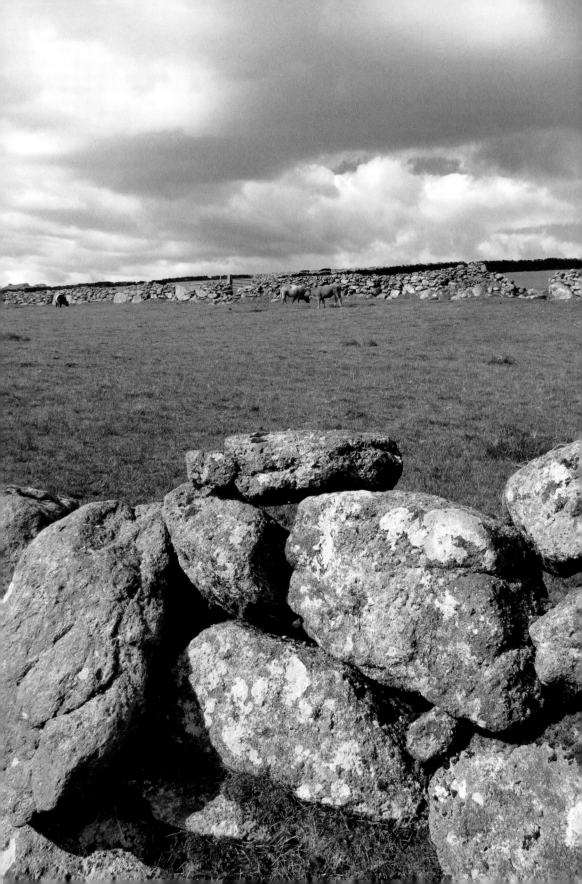

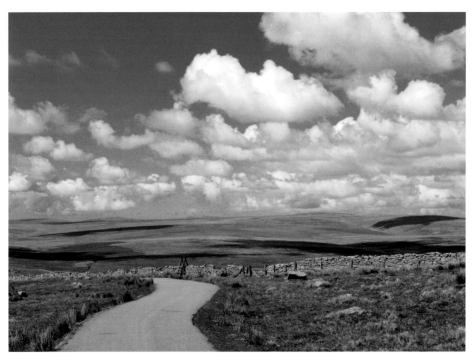

Beautiful Skies

The weather is constantly changing on Dartmoor from clear blue skies with fluffy clouds to dark foreboding skies full of rain. The change can be quite dramatic and it's easy to get caught in a storm with nowhere to shelter. Bad weather conditions can cause sudden flooding, which at times makes the area hazardous to walkers.

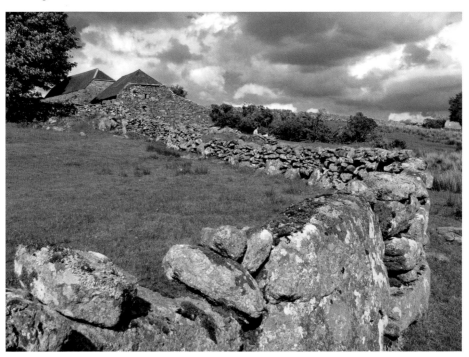

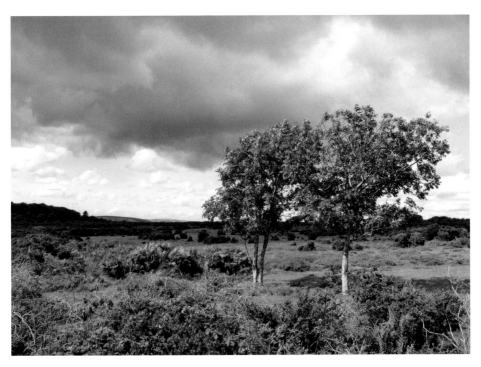

Heather Covered Moorland and Standing Stones

The standing stones found on Dartmoor date back to prehistoric times. The term 'menhir', meaning standing stone, refers to stones that are megalithic in size and stand apart from other monuments or burial mounds. Three of the most famous are Beardown Man near Cowsic Head, the Hanging Stone on Lee Moor, and the Harbourne Head near to Avon Dam.

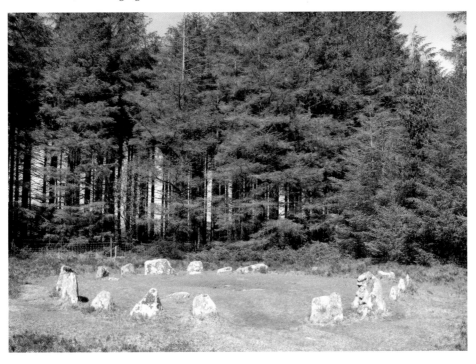

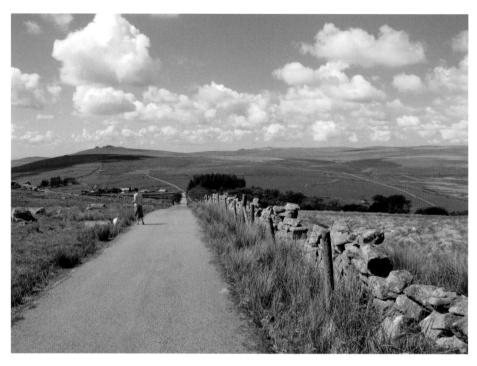

Dry Stone Walls

Dry stone walls have been built on Dartmoor for hundreds of years. They mark the boundaries of farms and are used to stop livestock from wandering. Dartmoor granite has been used as a building stone since the Bronze Age approximately 4,000 years ago.

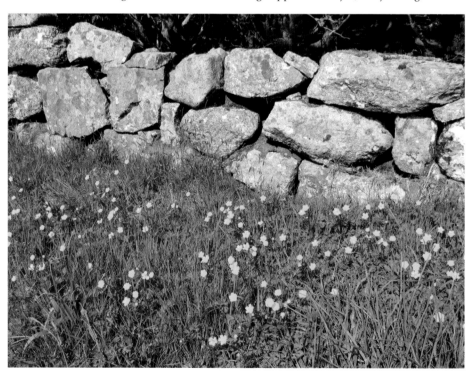

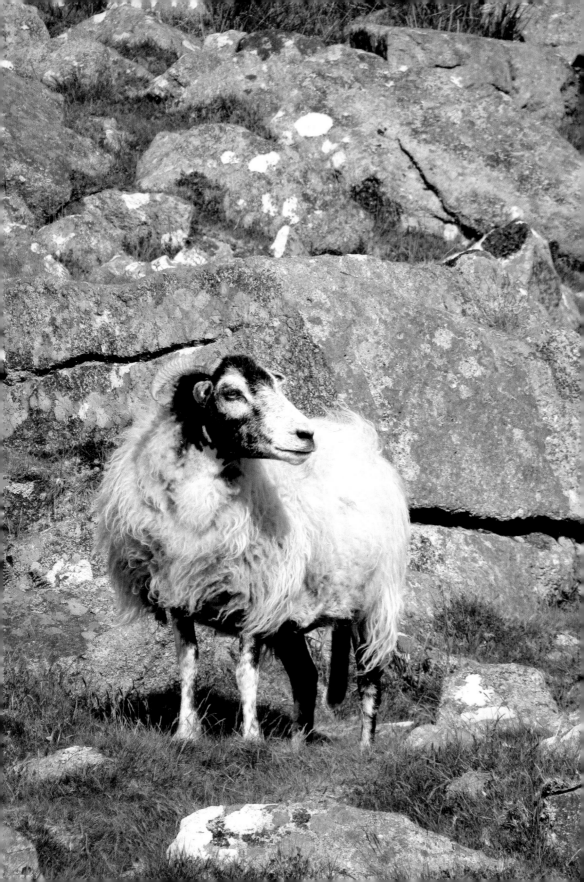

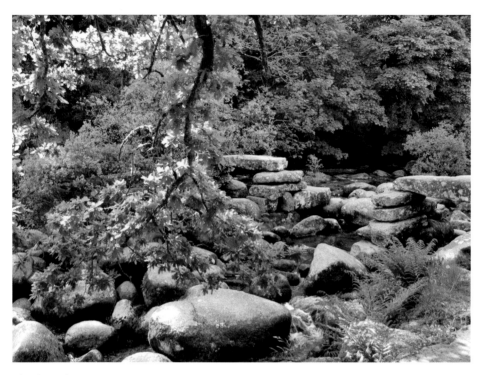

Flowing River at Dartmeet
The clapper bridge at Dartmeet dates from medieval times and is very popular with the thousands of tourists who visit the area every year. Dartmeet is the meeting place of two major tributaries of the River Dart: the East Dart and the West Dart. The road bridge approaching the attraction was built in 1792.

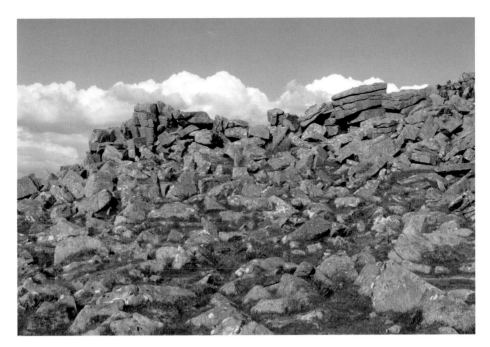

Granite Tors

The abundance of granite on Dartmoor has provided farmers with material for walls, posts and houses for many years. In the 1800s, granite was much in demand and a tramway was built from Haytor Down towards Stover Canal to transport it. In 1850, the quarries employed around 100 men, but just 8 years later the quarries were closed because of the availability of cheaper Cornish granite.

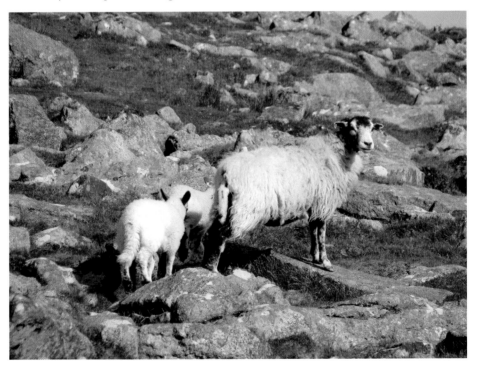

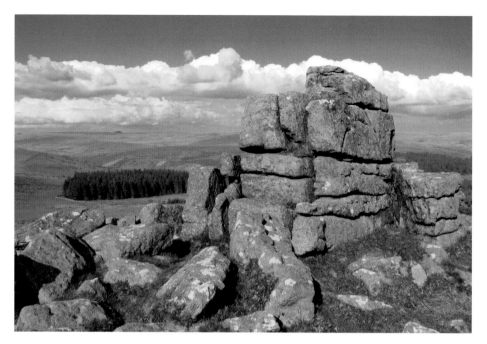

Stunning Views

Climbing to the top of one of the numerous granite tors on Dartmoor allows visitors to see for many miles. Much of the land is barren and was cleared of trees to produce farmland thousands of years ago. The trees and woodlands that remain are managed by the Dartmoor National Park Authority, who preserve native species such as oak, ash and hazel and remove invasive non-native species such as rhododendron, which can be found in abundance at places such as Burrator.

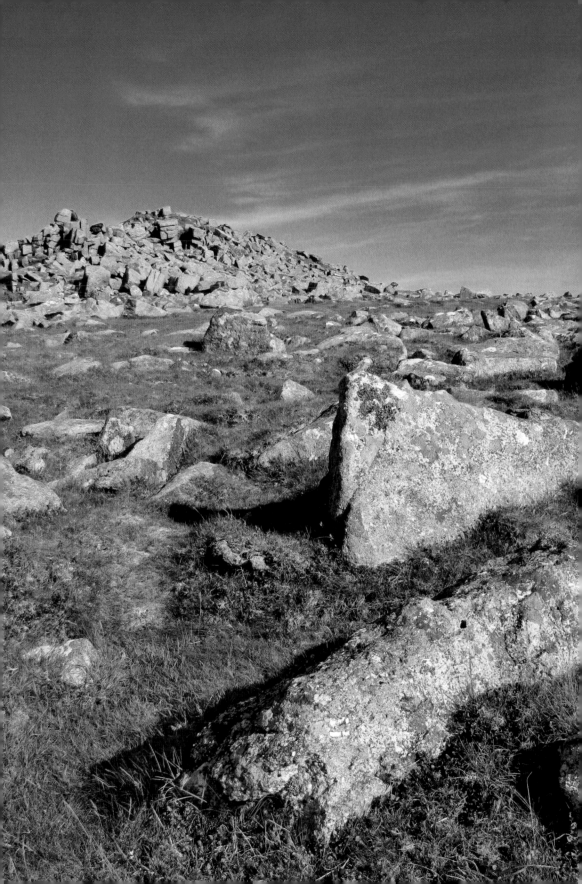

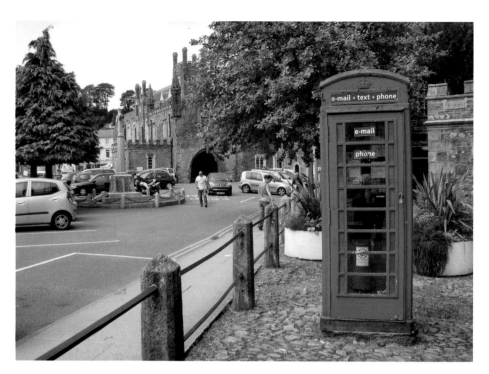

The Market Town of Tavistock

The market town of Tavistock can trace its history back to AD 961 when the Tavistock Abbey was founded. Its remains lie in the centre of the town. Sir Francis Drake was born in approximately 1540 at Crowndale Farm, which is to the west of where Tavistock College stands today. The two photographs show the area leading towards Bedford Square.

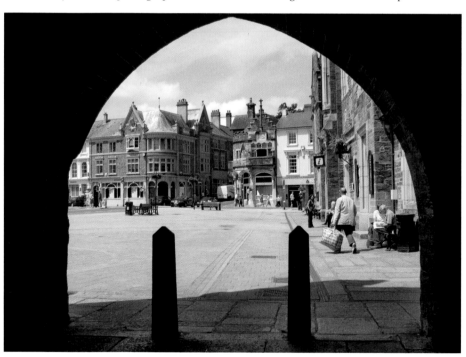

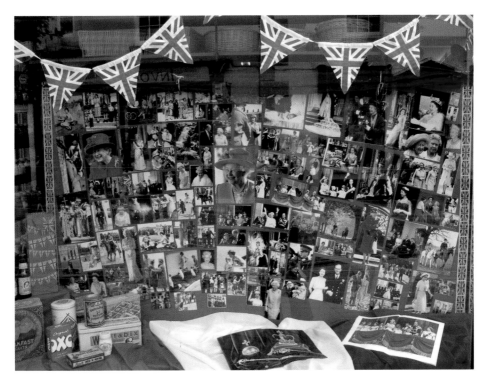

Local Shops and Produce

The first photograph shows a display in the shop window of N. H. Creber's grocer's shop in Tavistock celebrating the Queen's Diamond Jubilee. The shop in Fore Street was established in 1881 by John Carter and was originally known as 'Carter's Stores'. The second photograph shows locally sourced produce at a nearby greengrocer's.

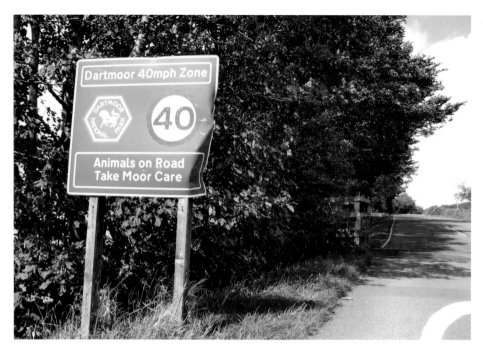

Dartmoor Ponies

Many Dartmoor ponies aren't pure breed and have been crossed with other varieties such as Shetland, Arab and Thoroughbred. Small herds can be found on the wilds of Dartmoor; many flock towards tourists in the summer for food. Foals are born between May and August. In late September and early October, ponies are rounded up and taken to market to sell.

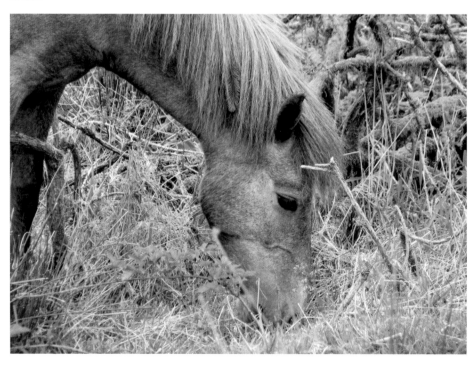

AUTUMN

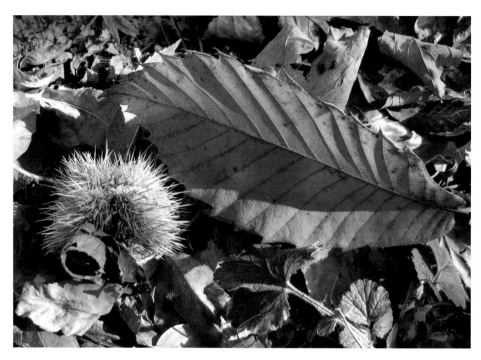

Autumn Spoils

As the leaves fall in autumn there are many spoils to be found including acorns, chestnuts and hazelnuts, which make food for small rodents such as dormice. The dense hazel coppice at Hembury Woods near Buckfastleigh is a particular haven for dormice. They can be hard to spot due to their nocturnal habits and because they spend their time either high off ground or hibernating.

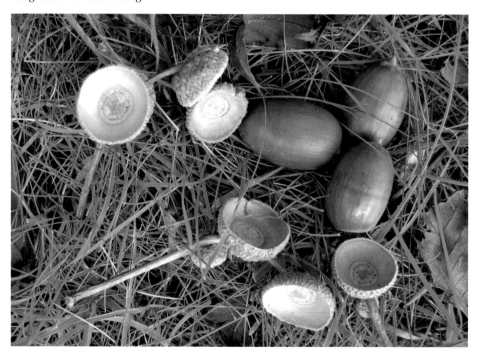

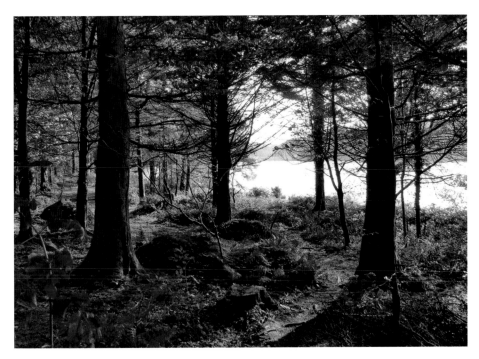

Burrator Reservoir

Autumn produces long shadows as the weather turns colder and the days grow shorter. An ideal place to take an autumn walk is beside Burrator Reservoir, where there is an abundance of wildlife, including deer, geese, ducks, squirrels, mice and occasionally wild boar. Boar have survived on the moor for many years but recent escapes from farms have greatly increased their numbers.

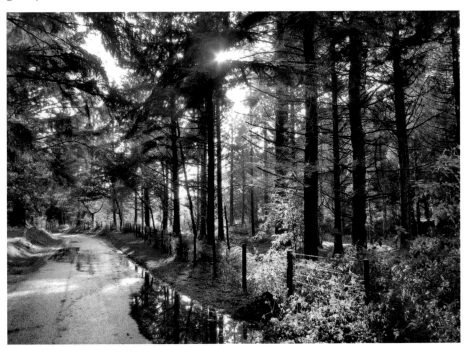

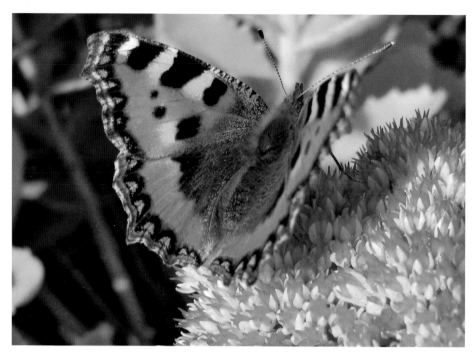

Beautiful Butterflies

With the milder weather, some butterflies can still be seen as late as November. Many varieties thrive near villages and wooded areas. Numbers of butterflies and other insects have declined dramatically but in parts of Dartmoor some species are making a comeback, although not in the numbers that they once were.

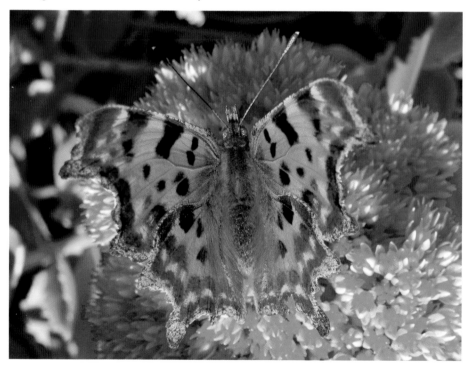

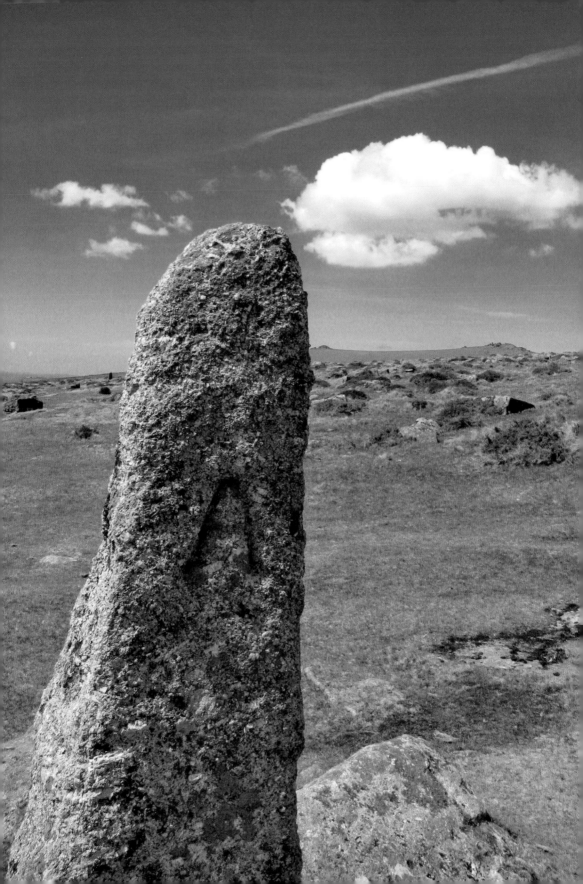

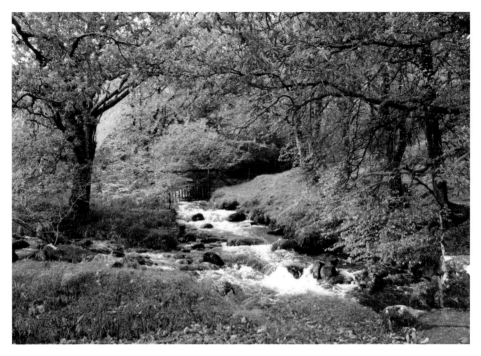

Autumn Leaves

Orangey brown leaves carpet the floors of wooded areas of Dartmoor in the autumn and can look quite dramatic. As the trees change colour there are many beautiful shades of browns and reds, making the area very popular with photographers. There's nothing like an autumn walk on Dartmoor, where one can admire the beautiful scenery with crisp, crunchy leaves underfoot.

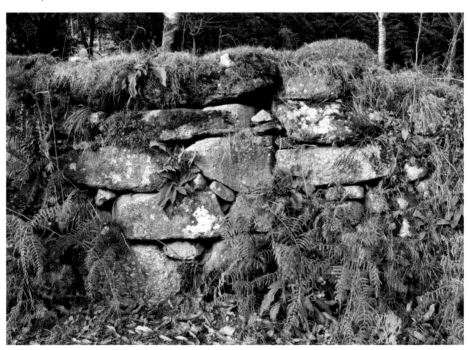

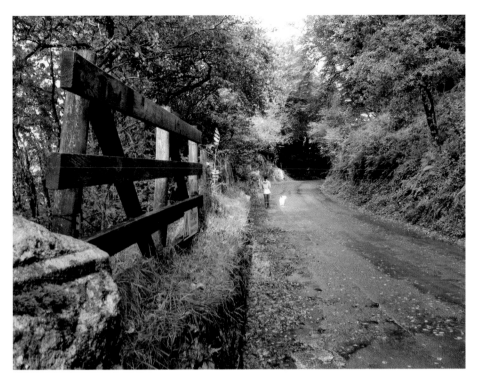

A Deer at Burrator

At one time it would have been quite rare to spot a deer at Burrator, but their numbers seem to be increasing in recent years. They seem less bothered by walkers and are often spotted just watching people pass by without the fear they once seemed to have. Wild boar have also been spotted in the area, but in fewer numbers in recent years.

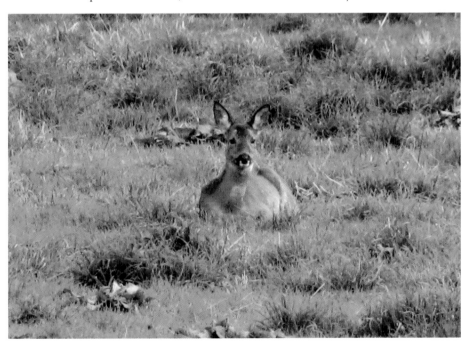

Burrator Reservoir

The reservoir at Burrator was completed in 1898 and extended in 1929. It is managed by the South West Lakes Trust and is popular with fishermen. The area is also popular with walkers, cyclists, photographers and birdwatchers. In cold winters, the reservoir had been known to freeze over.

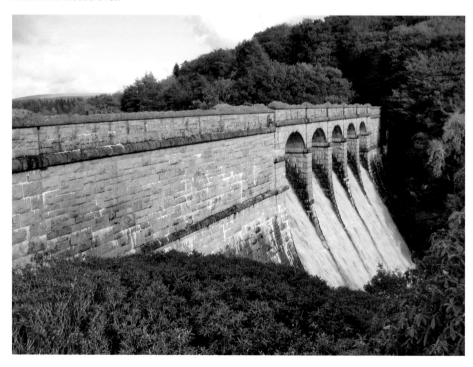

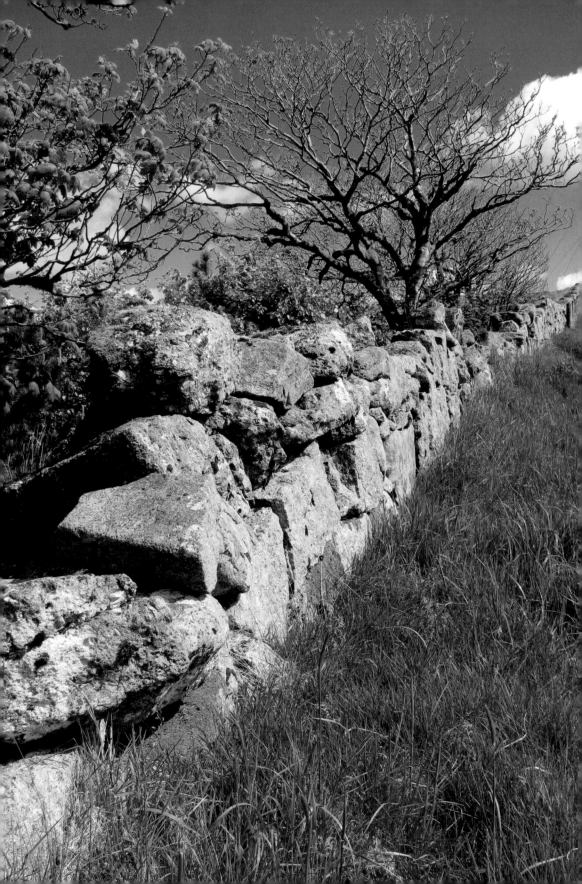

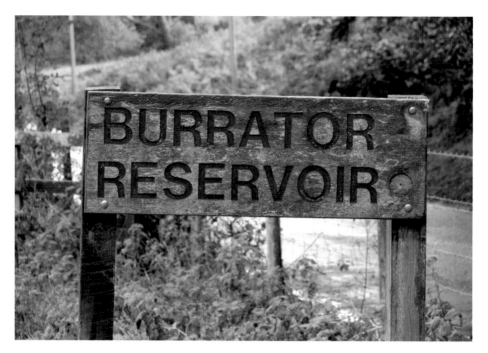

Autumn Days

The walk around Burrator covers a total of 3½ miles and takes around two hours to complete. It is a flat, easy walk and is ideal for families. The road is also popular with cyclists, horse riders and joggers. In times of drought it's possible to spot old stone walls and bridges that would normally lie beneath the water level.

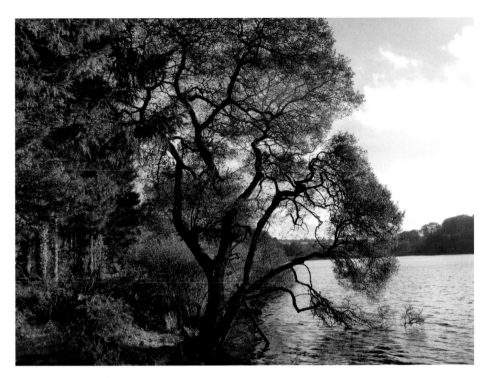

Burrator Reservoir

Various birdlife inhabit Burrator Reservoir. As well as ducks and native geese, Canada geese also visit the area regularly. Canada geese were first introduced to Europe in the 1700s and originally came from North America. They've been well established in the UK since the 1940s, although their numbers seem to have grown considerably in recent years.

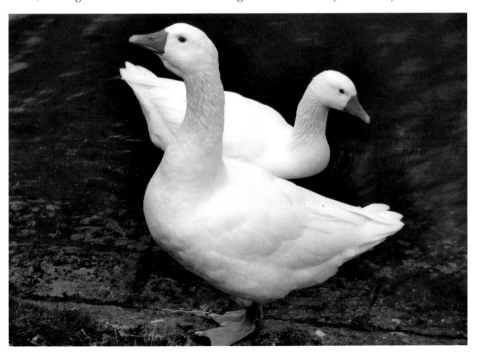

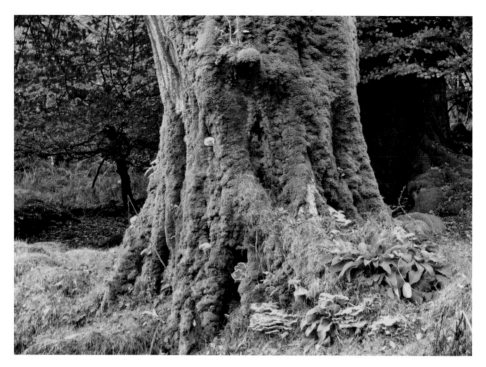

Autumn Trees & Fallen Leaves

Moss and lichen covered trees together with various species of fungi are found in wooded areas, especially where the ground is boggy and wet. Lichen points to the area being one with very clean air and can occur in the most extreme environments on Earth, including rocky coasts and hot deserts. Lichen is very sensitive to any form of pollution and can be useful to scientists when assessing air quality.

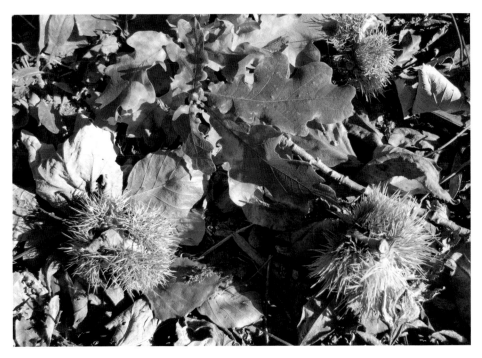

The Spoils of Autumn

Young boys once spent their spare time in the autumn searching for the fruit of the horse chestnut tree. Conkers were prized items and many hours were spent by boys with conkers on a piece of string competing to see who had the best. During the war years, horse chestnuts were also used as a source of starch. Horse chestnuts are slightly poisonous, although animals such as deer are able to eat them safely.

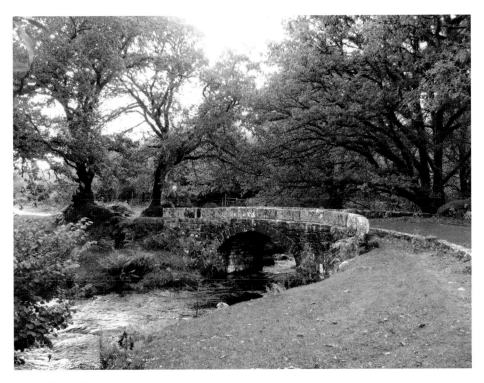

Beautiful Walks

There are many small bridges crossing the streams and brooks on Dartmoor. Most have been there for hundreds of years and have been used by farmers over the centuries to transport livestock and other produce such as grain.

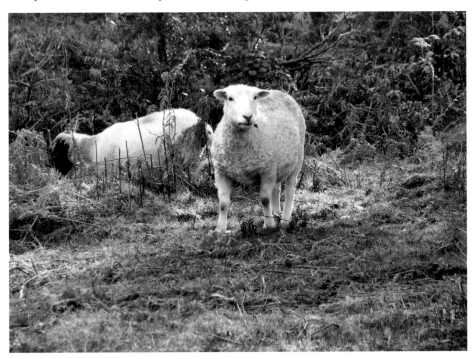

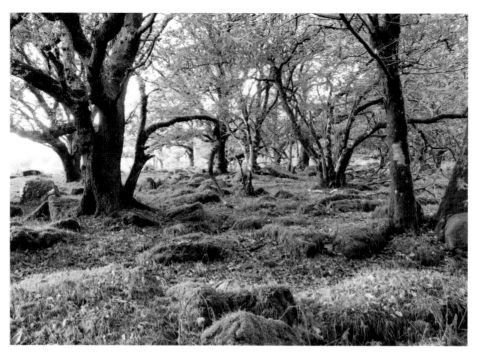

A Carpet of Leaves

Many of Dartmoor's older trees have been there for hundreds of years and are normally located close to human activity such as village greens, churchyards, ancient deer parks and wood pasture. They support much wildlife, including birds and bats, as well as being home to rare lichens and fungi.

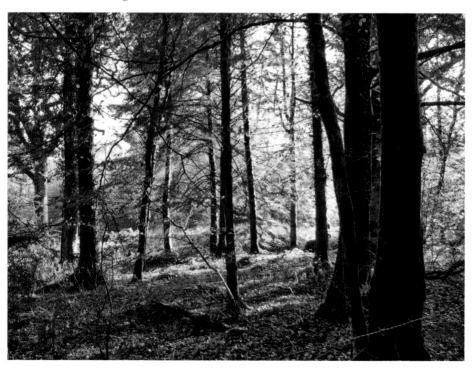

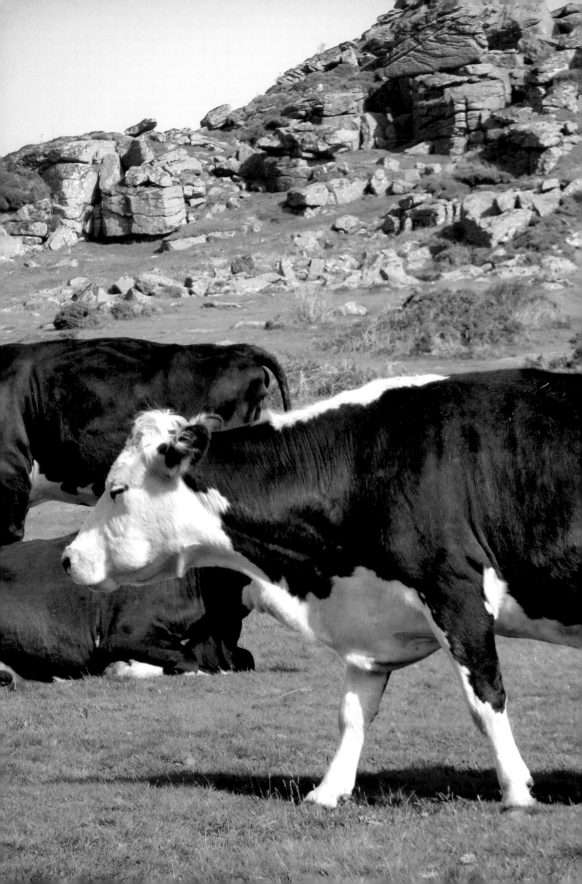

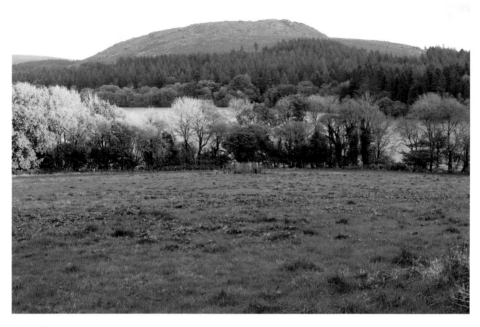

The View Towards Burrator

The photograph above shows the view looking towards Burrator Reservoir from the popular walking route that surrounds it. The field is popular with deer; there are two in this photograph but you'll need good eyes to spot them. The photograph below shows sheep grazing among the dying autumn ferns.

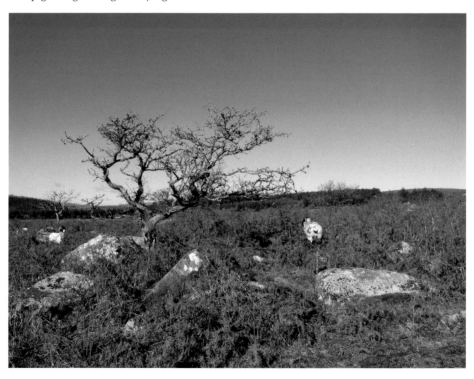

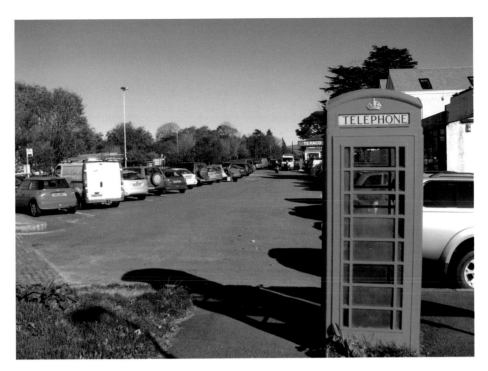

Telephone & Postboxes

Old red telephone and postboxes can be found all over Dartmoor. Many villages would rather keep them than have them taken away or replaced with modern ones. They add to the charm of an area, such as the one shown in the first photograph in the village of Yelverton. The postbox on the way to Burrator is accompanied with notices of local events.

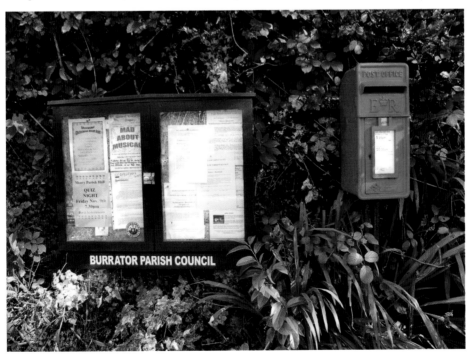

Felled Trees

Trees are cut down to provide posts for fences as well as for firewood. Their clearance also opens up the ground for grazing for sheep and other livestock. Before coal was readily available, trees would be pollarded to provide fuel. Pollarding is continued today, and trees are cut above the height of grazing animals. New shoots are then produced. This procedure greatly extends the life of a tree and veteran trees are regularly pollarded because of this.

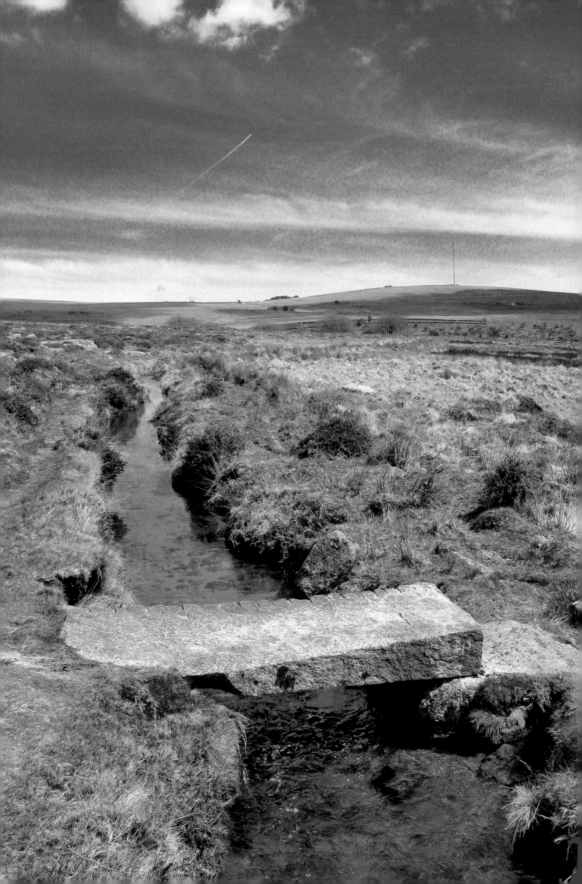

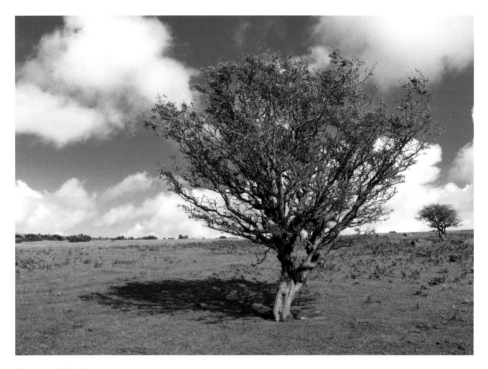

Autumn Shadows

Long shadows are produced across the land in the autumn light. Climbing high above the more common walks, towards one of the tors, lets you see the areas of woodland that still exist on the moor. Many gnarled and twisted trees, beaten by the weather, have survived for hundreds of years.

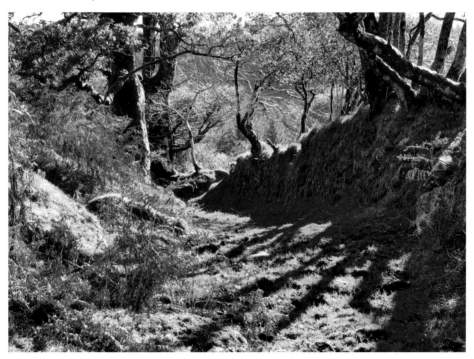

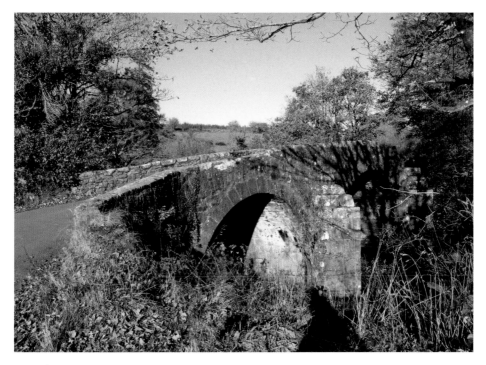

Stunning Scenery

Fallen leaves and glorious autumn colours can be seen in both photographs. Of the ancient trees on Dartmoor, probably the best known is the oak on the village green at Meavy. This tree is estimated to be over 950 years old. It was once propped up to stop it collapsing but has since been crowned and the props have been removed.

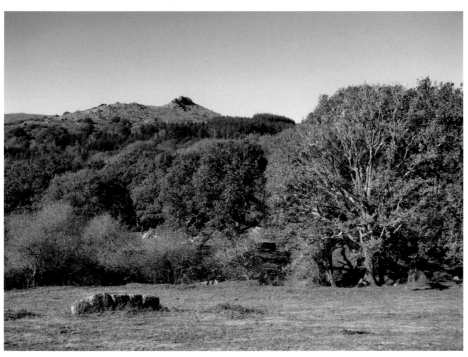

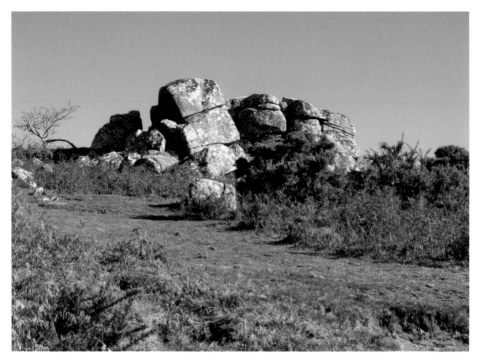

Grand Tors

There are many well-known tors throughout the moors including Hound Tor, Vixen Tor, Bellever Tor, Sheeps Tor and Fox Tor. There are approximately 170 major hills and tors across Dartmoor, and many are enjoyed by walkers and climbers. The photograph below shows a cow enjoying the autumn sun close to Sheeps Tor.

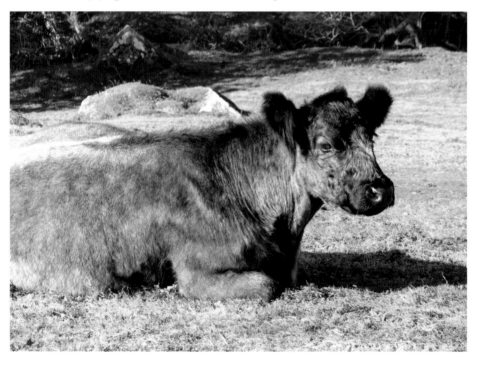

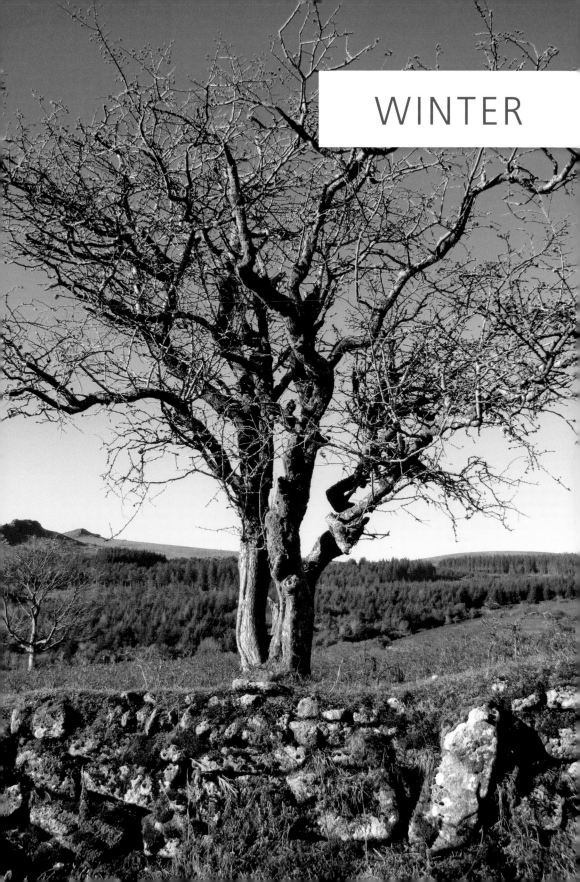

WINTER

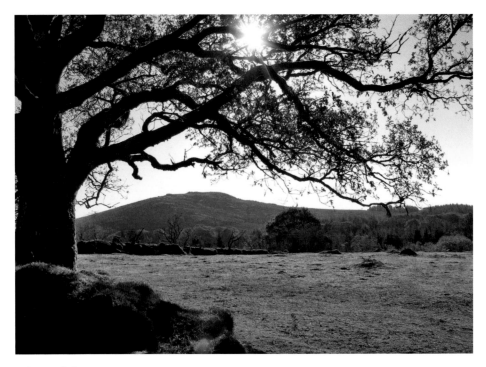

Winter Light

Winter brings shorter and colder days to Dartmoor often followed by flurries of snow. A lot of snowfall can completely cut off places like Princetown, and the moor can be a treacherous place for walkers during these times. Farmers struggle to feed and look after their animals, many of which are often scattered all across the moor.

Beautiful Moorland Walks

A crisp, dry winter day is an ideal one for a walk on Dartmoor. On colder days, snow flurries and frost can make many roads impassable. The photograph below shows the lonely telephone box near to Princetown after heavy rain has washed away a recent snowfall.

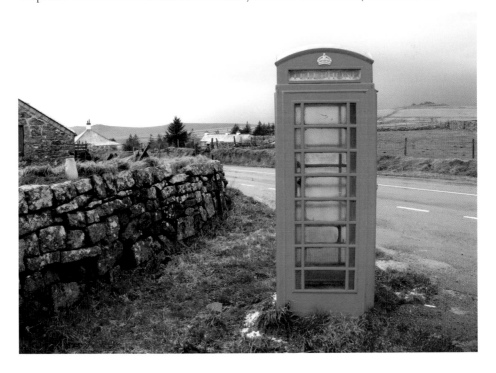

Shorter Days

The shorter, darker days of winter make it hard to enjoy a walk due to increasing wet weather, snow and thunderstorms. Some thunder and lightning on the moors can prove quite dramatic as well as dangerous to the walker. The photograph below shows a lone dog walker on a dark, cloudy evening near to the Pimple at Whitchurch.

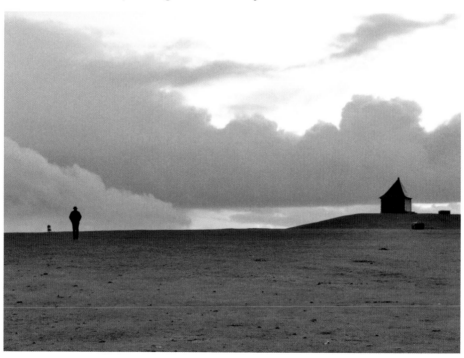

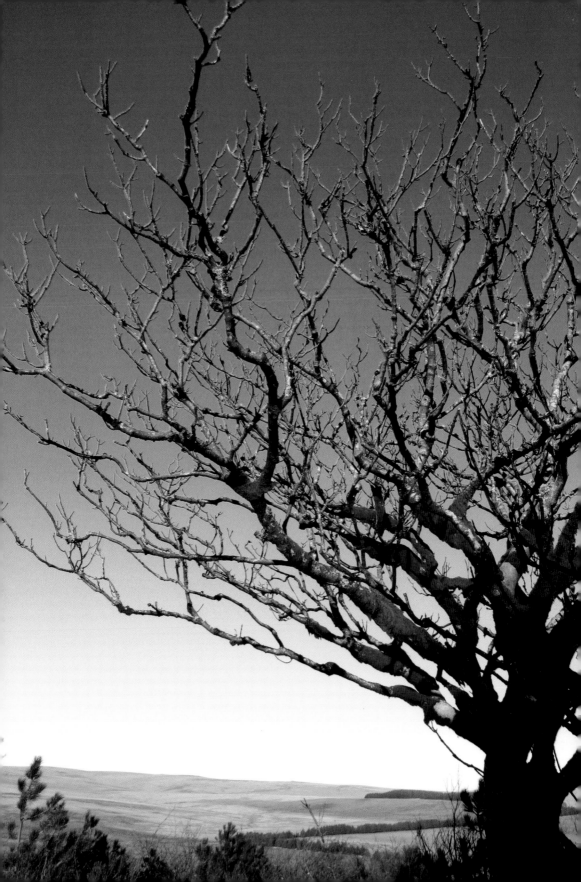

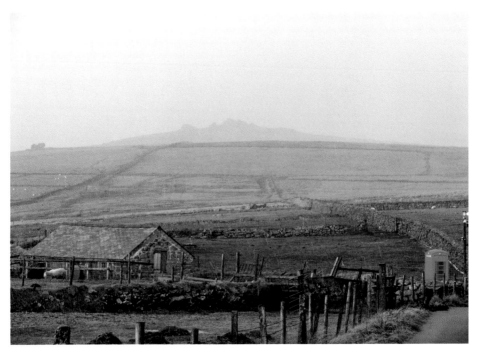

Dramatic Views

Climbing as high as you can and looking back over the moors allows you to see for miles in every direction. From a vantage point such as North Hessary Tor, you can see Plymouth and Princetown, many tors, including Kings Tor and Hollow Tor, as well as cairns, hut circles and disused quarries.

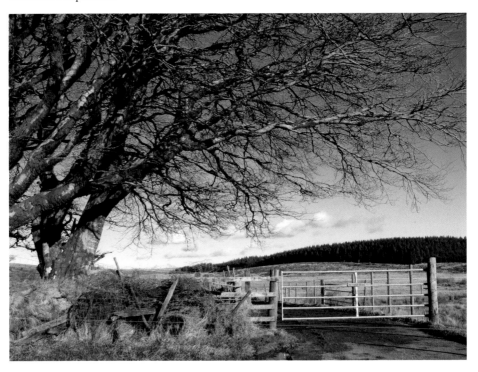

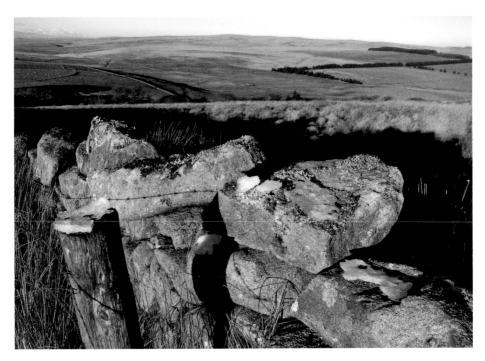

Frosty Mornings

Cold winter days can provide spectacular backdrops for photographers, as can dramatic snow scenes. Many birds forage for food as much of the ground freezes over. Small animals such as dormice settle into hibernation, as do hedgehogs, bats and some species of butterfly.

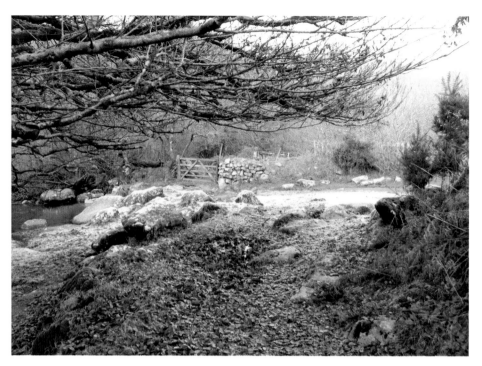

Icy Weather

Both photographs show icy weather at Belstone. The village of Belstone lies to the north of Dartmoor just above Belstone Cleave. The Nine Maidens, a stone circle from Bronze Age times, can be found close to the base of Belston Tor. Legend has it that the stones dance every day at noon.

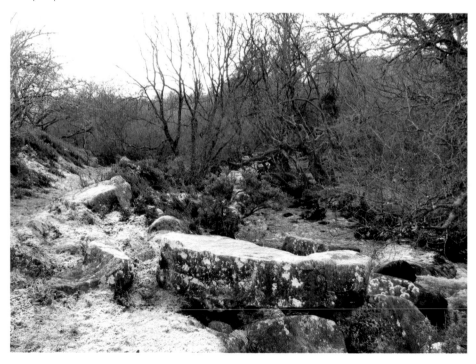

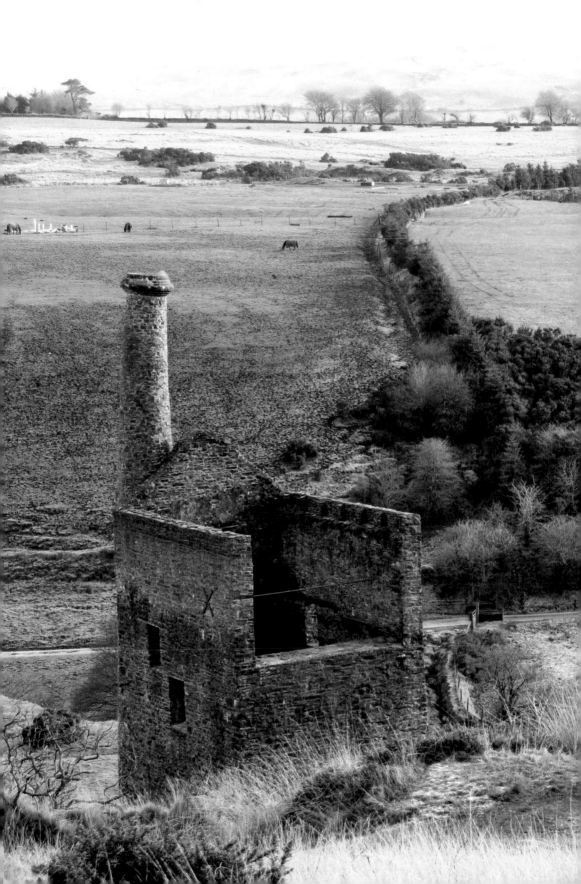

Remote Farms

There are many isolated farms on Dartmoor such as this one close to the Wheal Betsy mine. The mine was opened as early as 1740 and yielded zinc, lead and silver. It closed in the late 1700s but reopened in the 1800s. From 1821 to 1830, it produced 52,302 ounces of silver together with large quantities of pig lead and lead ore.

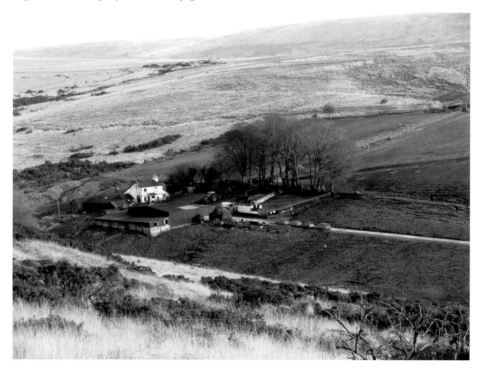

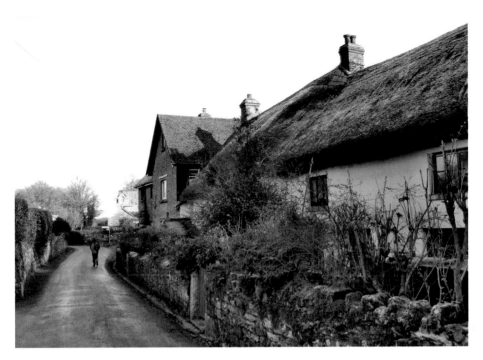

Thatched Cottages

There are many thatched cottages to be found on Dartmoor. Thatching consists of dry vegetation such as straw, sedge, water reed, rushes or heather. The practice dates back hundreds of years, and thatch was once the only roofing material available. There are approximately 1,000 thatchers still working in the UK.

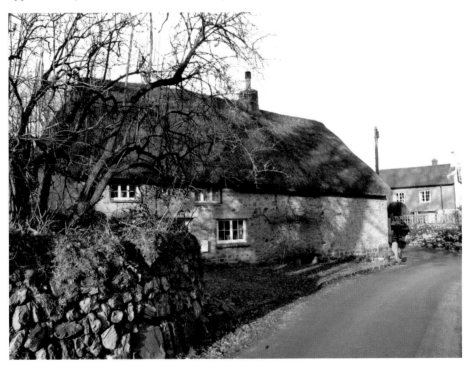

The Village of Belstone

The village of Belstone was featured in Eden Phillpott's novel, *The Secret Woman*, which was published in 1905. At the time of the novel, the small village expanded from nine farms and cottages when twenty-one new homes were built there. This transformed the community from an agricultural to a residential area. Many people weren't happy with the change at the time but Belstone still remains a small, quaint village.

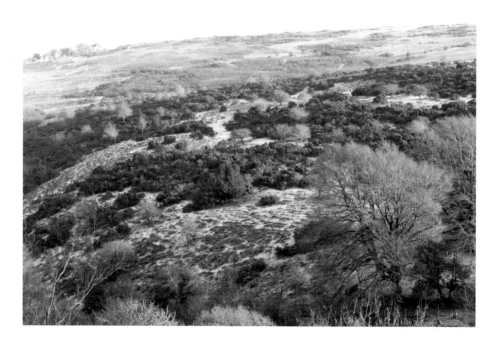

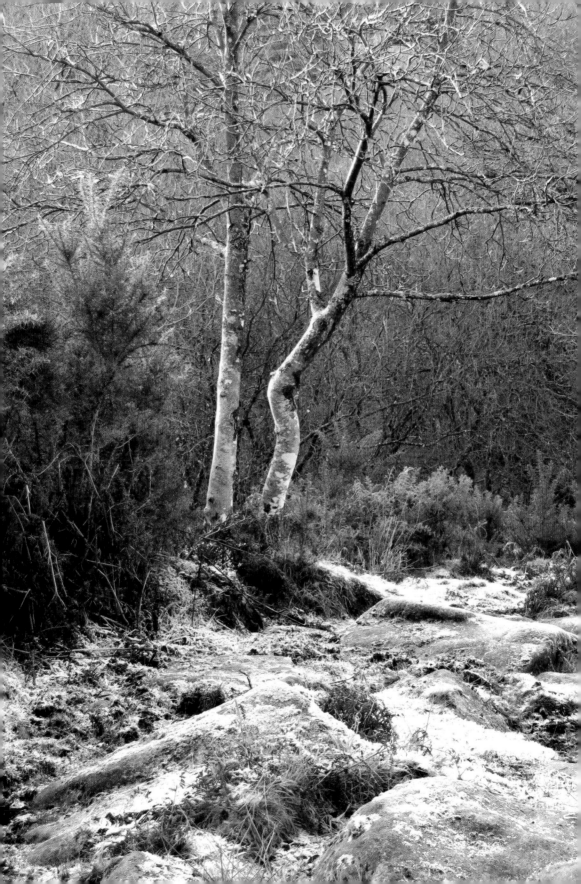

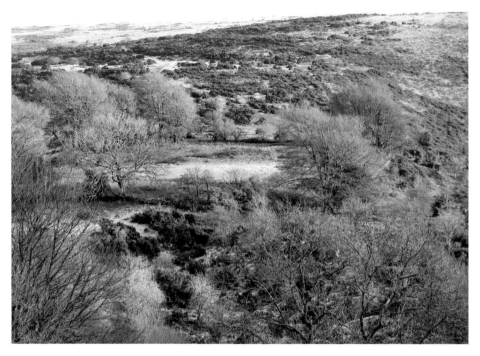

Frosty Weather

The icy view across Belstone Cleave is seen in the top photograph, looking from the village of Belstone. The wooded area lies between Belstone and Sticklepath and is very popular with walkers. The second photograph shows the cold, frozen ground on the walk, complete with autumn leaves, ferns and grass.

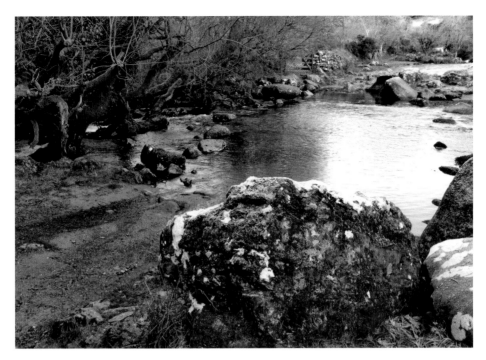

Cold December Days

Icy rocks surround an old crossing point on the river at Belstone Cleave. In recent times, a wooden bridge has been erected for walkers to cross the bridge with ease. The Dartmoor Way, Mary Michael Pilgims Way and the Tarka Trail all run through Belstone Cleave. The views from Cosdon Beacon stretch to Belstone Tor, Higher Tor and southern England's only mountains, Yes Tor and High Willhays.

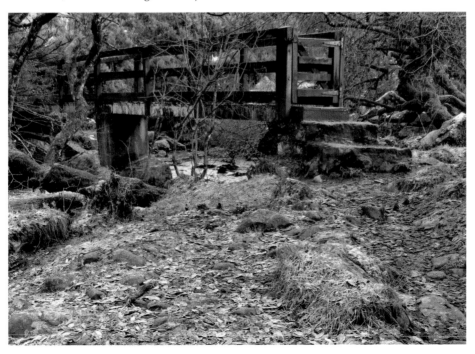

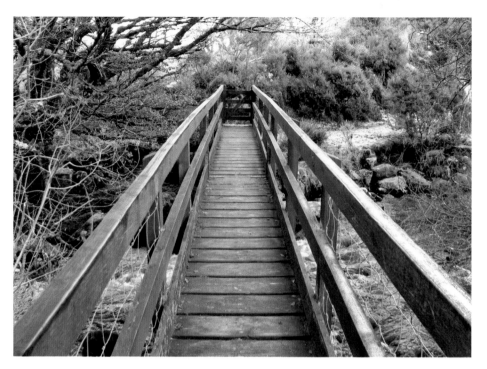

Icy Walkways

Both photographs show the River Taw running through the valley at Belstone Cleave. The Taw flows from the high moors, passing Cranmere Pool and travelling through Steeperton Gorge past Taw Marsh before reaching Belstone. As the river leaves Dartmoor National Park, it flows towards Bideford Bay.

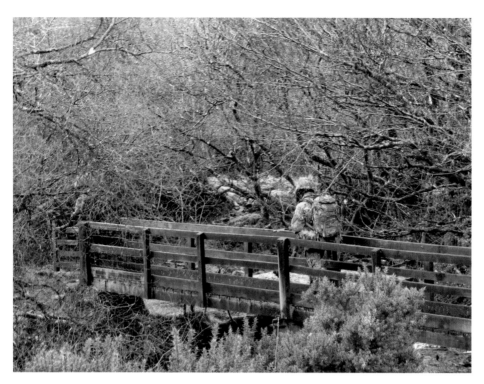

Army Manoeuvres at Belstone

Both photographs show members of the Army marching in the area of Belstone in heavy camouflage. The MOD currently has the right to train on 14 per cent of Dartmoor, some of which it owns outright. Live firing takes place at Merrivale, Oakworthy and Willsworthy.

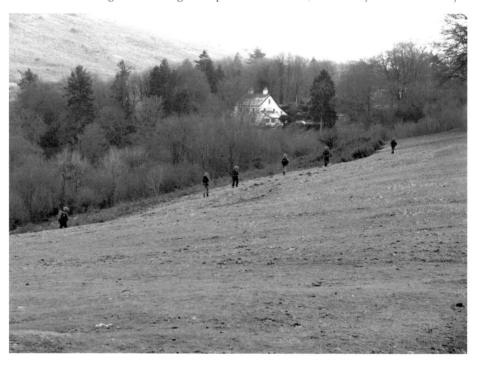

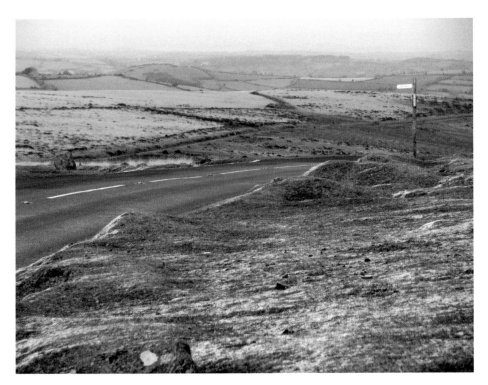

Quiet Moorland Roads

As the roads freeze up towards the end of the year, many become treacherous or impassable. The moors become less popular with walkers and tourists, but there is still much to see and do in the many villages. The second photograph shows a bakery in Chagford, which sells bread, warm pies and pasties – ideal on a cold winter's day on Dartmoor.

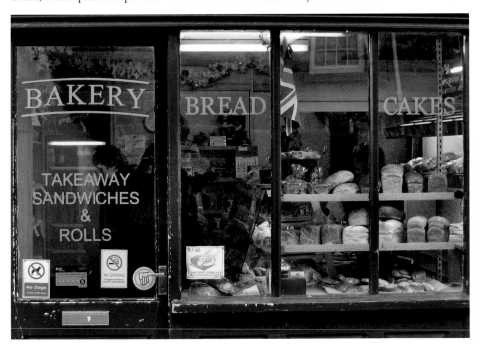